BREWING IN GLOUCESTERSHIRE

GEOFF SANDLES

AMBERLEY

First published 2016

Amberley Publishing
The Hill, Stroud
Gloucestershire, GL5 4EP

www.amberley-books.com

Copyright © Geoff Sandles, 2016
Maps contain Ordnance Survey data.
Crown Copyright and database right, 2016

The right of Geoff Sandles to be identified as
the Author of this work has been asserted in
accordance with the Copyrights, Designs and
Patents Act 1988.

ISBN 978 1 4456 5551 2 (print)
ISBN 978 1 4456 5552 9 (ebook)

British Library Cataloguing in Publication Data.
A catalogue record for this book is available from
the British Library.

Typesetting by Amberley Publishing.
Printed in the UK.

Contents

Acknowledgements

Many thanks to Johnny Arkell, Annie Blick, Lucy Cordrey, Tim Edgell, Chris Evans, Emma Lanfear, John Morgan, Kathy Sandles, Mark Sandles, John Saunders, Michael Wilkes, Chas Wright.

Introduction

Any attempt to accurately document the existence of every brewery, large and small, that has ever existed in the county of Gloucestershire would be an ambitious project and certainly not definitive as brewing has been carried on in the county, in some form or another, since the Roman occupation and possibly before that. In medieval times, brewing took place in large households, farms, colleges, monasteries and most inns.

In 1840, there were almost 50,000 common brewers and home-brew premises in the United Kingdom, yet forty years later, there was less than half that number, and by 1900, the number had declined to just over 3,000. The Industrial Revolution and the coming of steam power enabled the breweries, especially in urban areas, to churn out good quality beer in large quantities. The size of a brewery was originally limited by the delivery area that could be reached by horse and dray. Thus began the beginning of the 'tied-house' system where ownership of pubs in close proximity to the brewery secured guaranteed outlets for their ales and stouts.

The onset of the First World War and general economic depression reduced the demand for beer, and many established commercial breweries either closed or amalgamated with their neighbours to minimise losses. Licensing hours were imposed and the strength of beer significantly decreased. The problems were confounded during the Second World War with restrictions on supply resulting in a far inferior product than what was brewed just fifty years before. After the Second World War, a period of austerity did little to improve the quality of beer and, coupled with bad cellar management in pubs, led to a situation where traditional draught beer began to be replaced by crystal clear processed beer in metal kegs. West Country Breweries introduced their Gloster Keg in the late 1950s, but it was the national launch of keg beers that set the alarm bells ringing for discerning beer drinkers. Watney's Red Barrel was heralded as a Red Revolution but now, on reflection, can be seen as the impetus for the establishment of the Campaign for Real Ale in 1971 (CAMRA), which set out to highlight that keg beers were lacking in flavour, excessively gassy and could not match the proper taste to be enjoyed in well-kept traditional cask beer.

The Donnington Brewery, near Stow on the Wold, is generally recognised as the most picturesque brewery in the whole of the United Kingdom. In 2015, it celebrated

its 150th anniversary and throughout its history has been producing superb Cotswold traditional ales almost exclusively for its small tied estate. Brewing good beer should be about passion and a commitment to quality and those virtues are entrenched in the philosophy at Donnington Brewery and now extend to the new generation of micro-breweries that are flourishing in Gloucestershire today. There is a renewed impetus on brewing practices with exciting flavours being derived from continental hops with high bittering qualities. With a delightful degree of irony, some local brewers, such as Deya from Cheltenham and the Gloucester Brewery, are even packaging some of their high-quality beers in the new generation of kegs, eschewing the traditional cask.

With such a proliferation of excellent micro-breweries operating in Gloucestershire today, there is an amazing choice of locally brewed beer out there to be discovered. For the purpose of this book, I have confined my research to the present county boundary, and I have not included those breweries that are now located in Bristol and South Gloucestershire.

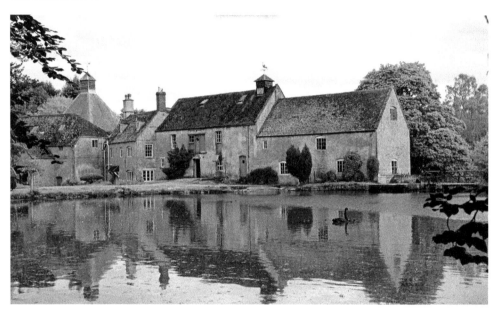

Donnington Brewery – a Cotswold jewel.

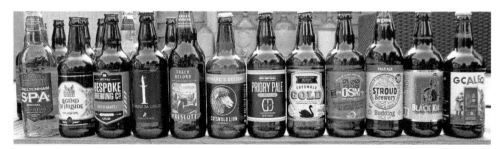

Gloucestershire beers. Such an amazing choice.

Bygone Family and Commercial Breweries

Pubs making their own beer for consumption on the premises were once common, but the brewing was done out of necessity rather than commercially, and it was not until the middle of the nineteenth century that such home-brewed houses began to be documented for licensing regulations. However, by 1831, only 45 per cent of beer was still home-brewed in the pub. An 1863 Post Office Directory for Gloucestershire and Bristol lists seventy-two brewers but does not differentiate between beer retailers (by definition not brewers at all), home-brewed houses and commercial breweries. Pubs that still trade today that once brewed their own beer include the Bayshill Inn, Exmouth Arms and Norwood Arms in Cheltenham and England's Glory (New Inn) and Pelican Inn in Gloucester. Probably, the last original home-brew pub to operate in Gloucestershire was the Nelson Inn in Gloucester Street Cirencester that was still brewing in 1930.

 Contemporary and succeeding these home-brewed pubs were small commercial brewing concerns supplying beer to their own tied-houses. In Cheltenham, there were breweries in Gloucester Road (Albion Brewery), Warwick Place (Anchor Brewery), and Albion Street (Stibbs & Co., Steam Brewery). There were similar small family brewers in Gloucester and elsewhere throughout the county. One such

EDMUND JOHN PRICE,

THE NELSON HOME BREWING BREWERY,

CIRENCESTER,

Is still Brewing Pure Home-Brewed Beer. These Fine Ales are used and recommended by the leading Medical Practitioners throughout the District as a Pure and Wholesome Beverage.

Nelson Home Brewery.

brewery was Arthur Vincent Hatton's Northgate Brewery near the GWR station in Gloucester. In 1896, he had sold the business to Ind Coope Ltd of Burton on Trent, an expansionary regional brewery that used the railway infrastructure to transport their beer to newly acquired pubs considerable distances away from their homeland. The Burton on Trent and Birmingham breweries generally failed to acquire any other established business in Gloucestershire, but their influence was considerable. The Vauxhall Inn in Barton Street Gloucester was sold to Mitchell & Butler's of Cape Hill,

RIGHTON & CO.,

Anchor Brewery,

WARWICK PLACE, CHELTENHAM.

ALE AND PORTER BREWERS,

SPECIALLY BREWED FROM THE TOWN WATER.

WINE AND SPIRIT MERCHANTS

AND

MINERAL WATER MANUFACTURERS.

FAMILIES SUPPLIED WITH CASKS OF ALL SIZES.

Anchor Brewery, Cheltenham.

NORTHGATE BREWERY.

HATTON'S

CELEBRATED STOUT, AT 1s. 2D. AND 1s. 4D. PER GALLON,

IN ANY SIZE CASK, FROM FIVE GALLONS UPWARDS.

THIS STOUT is strongly recommended by Medical Gentlemen for its strengthening and invigorating properties; and is pronounced equal to the Dublin, which is sold at much higher prices.

Northgate Brewery, Gloucester.

Birmingham for £6,050 in 1899 and was completely rebuilt at considerable expense with a grandiose and elaborate green-tiled exterior that can still be admired today although the building is now in use as a mini-supermarket. The lavish expenditure effectively showcased the refurbished pubs as welcoming superior establishments, in stark contrast to the rundown 'spit and sawdust' basic locals offered by the local brewers.

Some family-based brewers opted to brew exclusively for the free trade rather than concentrate on supplying their own local tied estate. One such concern was Carpenter & Co.'s Cainscross Brewery near Stroud. Almost entirely dependent on advertising to promote their beers, they boldly proclaimed in 1909 that their beers were 'for the better classes'. The *Stroud Valley Illustrated* noted that their Family Pale Ales were 'brilliant and sparkling, delicate in aroma, appetising to the palate and giving tone to the constitution'. The Cainscross Brewery was put up for sale in April 1926 with a fourteen-quarter mash tun and forty-barrel copper, potentially giving an output of 11,520 pints per brew, a risky business considering there were no guaranteed pub outlets. Just up the road in Cashes Green was the Hamwell Leaze Brewery, operated by Cordwell & Sons. Their brewing licence in 1895 stipulated that they could not sell beer to the public in quantities of less than a pin (four-and-a-half gallons), and with such restrictive legislation, it is little wonder that Cordwell & Sons went bankrupt in 1907. However, with a revised licence, a new company was formed and free trade outlets were secured as far away as Tewkesbury and Bristol. Brewing at Hamwell Leaze came to an end during the Second World War because of staff shortages and the loss of suppliers. Cordwell's continued to operate as beer bottlers until 1957.

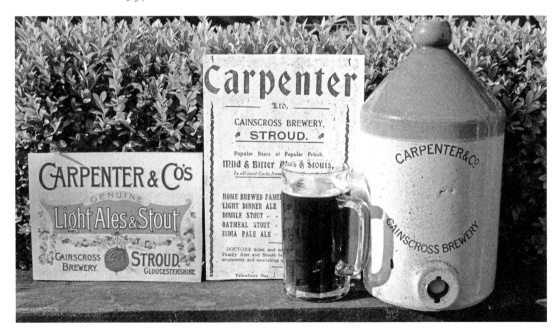

Carpenter & Co., Cainscross Brewery.

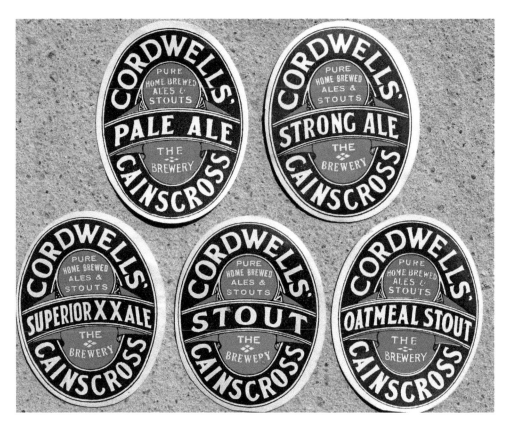

Cordwell's Hamwell Leaze Brewery, Cashes Green.

It is a little-known fact that Arthur Guinness once had a brewery in Gloucestershire. A direct descendant from the famous Guinness Dublin Brewery family line, Arthur Hart Guinness was the owner of the Coombe Valley Brewery near Wotton-under-Edge from the 1880s. Operations at the Coombe Valley Brewery then continued under the brief ownership of Maj. Annesley and then by Sidney Underhill. Trading continued as the Coombe Valley Brewery Co. Ltd until the receiver was called in to liquidate the company in March 1908. The auction took place on 6 July 1912, and the particulars of sale included a six-quarter mash tun and a copper capable of boiling nineteen barrels. At the beginning of the First World War, the premises were used for mineral water manufacture, and the licence to brew beer expired in 1918.

The Forest of Dean has seen many breweries come and go. The story of Francis Wintle's Mitcheldean Forest Brewery will be explored in later chapters. There were two breweries in the village of Redbrook, straddling the Gloucestershire and Monmouthshire border. Confusingly, both traded under the name the Redbrook Brewery. A brewery was established in Coleford in 1832 at the Spout. Forest of Dean Steam Brewery was established in 1867 in Blakeney, and in 1890, the owner was Samuel Price Scrivenger Evans. The Blakeney Brewery was purchased by Arnold, Perrett & Co. in 1897, and the brewery was closed.

Right: Combe Valley Brewery.

Below: An advertisement claimed that the beer was 'eminently suited to the dry and thirsty customer'.

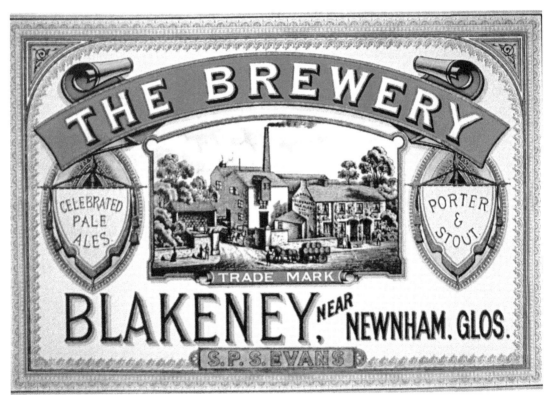

The fortunes of the country-based breweries were dependent on an owner's management skills, and bad decision-making on their part could lead to financial disaster. Take, for example, the case of the Dursley Brewery that failed under the ownership of a would-be entrepreneur. Thomas William Elvy was born in London in 1855. His father ran a successful wine and spirit merchants that traded as Marshall and Elvy. Thomas went to work at the firm as a clerk in 1874 and became a partner in the business in 1884. When his father died in 1892, Thomas remained in the employment of the business until he left in December 1897, receiving a substantial dividend of £16,000. In June 1899, Thomas Elvy had invested his monies into the purchase of the Dursley Brewery from Messrs King and Worsey but had to raise £28,000 for the sale price. He borrowed money from his brothers, and the remainder of the purchase price was put on mortgage. In the 1901 census, Thomas and his wife Jane are residing at Bisley Old Road in Stroud with their two daughters, son, father-in-law, sister-in-law and employing four servants. The subsequent acquisition of six pubs on borrowed money was a poor financial decision, and it is little wonder that bankruptcy ensued in 1906. The court heard that the cause of failure was a large expenditure on licensed properties and personal expenses exceeding income for several years. The Deputy Official Receiver stated that in seven years Elvy had lost something like £33,000. In 1902, his income was £560, yet he spent £2,556. Elvy told the court: 'I've no defence; I freely admit it: I've done wrong.' The twenty-one licensed houses were sold by private treaty to Messrs Godsell & Sons of Stroud, and when the brewery was put up for auction in May 1907, it failed to reach reserve and was withdrawn at £2,500.

James Smith (born 1804) was a coal merchant in 1851 but had diversified to become a brewer and coal merchant in Brimscombe ten years later. The Brimscombe Brewery

A present-day reminder of the Brimscombe Brewery.

passed into the ownership of his son Charles after his death in 1869. Charles Smith developed the business into a successful company that, by 1881, was employing fifteen men. His brother William was a co-partner but left the family business by 1891, only to return a few years later to become the chairman. Continuing with the family tradition, both Charles and William's sons became involved in the brewery when they became of age. Some thirty-seven pubs were supplied with Smith & Sons Brimscombe ales. However, the glory days of the brewery were short-lived, and the onset of the First World War adversely affected trade such that on 30 December 1913, William Smith appointed a liquidator to wind up the company. The family business of Smith & Sons was offered for auction in September 1915 with twenty-two public houses in the property portfolio. At the auction, the public houses raised £18,075, but the brewery was not sold until 1919 when it was bought by the Stroud Brewery Co Ltd.

An innovative and possibly unique approach to securing continued sales in times of economic and social downturn is exemplified by the decision of Combe's Brockhampton Brewery near Andoversford to concentrate on the production of home-brew kits from as early as the 1920s. The Combe family had acquired the Brockhampton Brewery in 1840 and supplied pubs in Winchcombe (Plaisterer's Arms) and Cheltenham (Kemble Brewery Inn). Reginald George Bradford Combe realised that the beer trade was generally in decline after the First World War. His decision to diversify into pre-packaged home-brew kits had one serious drawback – customers had to have a Brewers Licence to legally brew beer at home. Nevertheless, the brew-kits were successful and continued

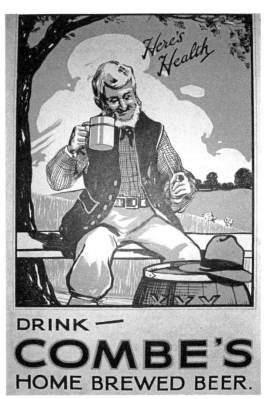

Combe's Brockhampton Brewery.

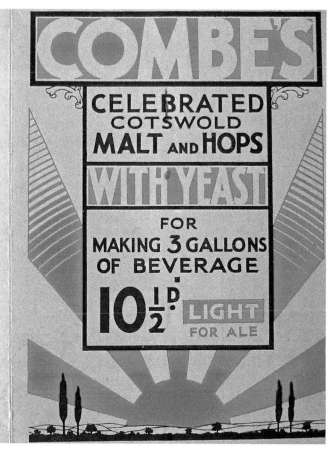

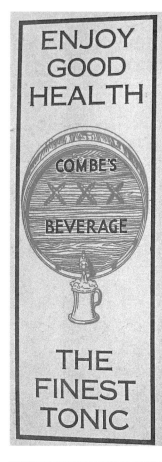

Above: An early home-brew kit.

Left: Three gallons for less than a shilling!

Above: Combe's Brockhampton Brewery.

Right: Kemble Brewery Inn, Cheltenham.

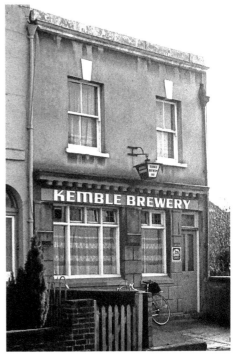

until the Second World War when the shortage of sugar led to the end of production. Brewing proved to be challenging and ceased in 1927 when the pub estate was sold to Showell's Brewery Co. Ltd of Oldbury (later part of Ind Coope). Brockhampton Brewery itself was not included in the sale and malting continued on site, supplementing the sales of pre-packed hops – from quantities from 7 lbs to 112 lbs. The brewery building and malthouse was taken over by the Ministry of Defence during the Second World War, and the Northumbrian Div. was billeted there on their return from Dunkirk.

Pigot's Directory of 1822–23 lists Joseph Cripps as a brewer in Cirencester. His brewery was located behind the Bell Inn in Cricklade Street. In the 1841 census, Frederick Cripps aged thirty-three, is listed as a brewer and banker. Joseph later became a magistrate and throughout his working life directed Cripps Brewery from humble roots to a successful commercial business that operated from their enlarged brewery in Cricklade Street. Edward Bowly's Cotswold Brewery in Watermoor Road with their sixteen pubs was sold to Frederick Cripps in 1882. In 1887, the family business was registered as the Cirencester Brewery Co. Ltd, enabling further expansion. When Frederick Cripps died in 1889, he had a personal fortune of £90,000. He left his house and other properties to his nephew Edmund William Cripps. Edmund died in December 1899 aged fifty-six and left in his will a considerable fortune of £194,482 gross. By 1920, the Cirencester Brewery Co. owned ninety-two pubs. A 1930s price list from the Cirencester Brewery gives details of the beers brewed. On draught, which were supplied in four-and-a-half gallon casks upwards, were Mild Ale, Bitter Ale, Pale Ale, XXXX and Stout. Bottled beers included Cirencester Pale Ale and Cirencester Extra Stout.

This view of the parish church would have once been obscured by the Cirencester Brewery.

Right: Ledger for the Kings Head, Withington.

Below: A seventy-two-gallon cask of ale for £3 12s 0d!

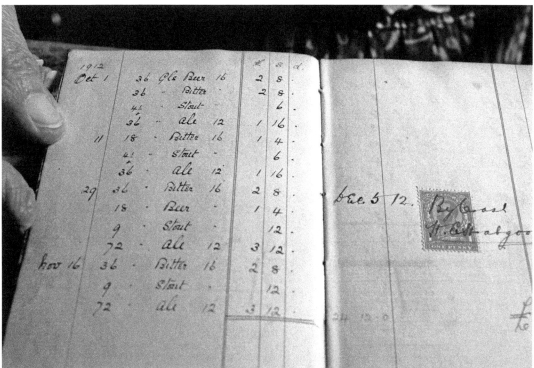

Now apartments.

The Cirencester Brewery was acquired by H. and G. Simonds of Reading in June 1937 with ninety licensed properties. The decision was taken to cease brewing at Cirencester and supply the pubs with beer from W. J. Rogers' Bristol Brewery, which had itself been taken over by Simonds in 1935. The Cirencester Brewery continued trading in name only, and the Cricklade Street site became no more than a distribution depot. Mr W. P. Cripps was even appointed as a director at Rogers Brewery. The Second World War and the austerity years that followed no doubt contributed to the decision to put the Cirencester Brewery Ltd into voluntary liquidation in December 1948, and the assets were merged into the parent company of H. and G. Simonds. In 1960, Simonds were acquired by the Courage Group and 1,200 tied-houses and hotels passed into the ownership of the national brewer. Brewing at the old Simonds Reading brewery ceased in 1979.

For Gloucestershire beer aficionados, Donnington Brewery is a much-loved family institution that has somehow managed to survive, unspoilt by progress, for generations. Thomas Arkell bought the picturesque thirteenth-century Donnington Mill near Stow on the Wold in 1827, which had previously been used for both milling corn and wool manufacture. In 1865, Thomas and his nephew Richard Iles Arkell converted the mill into a brewery. Richard realised that the pure water of the River Dickler was perfect for brewing beer, and the mill race and water wheels could provide power to the brewery. In 1952, after his service in the Royal Air Force, Claude Arkell inherited the Donnington Brewery from his father Herbert. Claude ran the brewery for fifty-five years until he sadly died in June 2007, aged eighty-nine. The brewery was bequeathed to cousin Peter Arkell and his son James of the Kingsdown Brewery in Swindon. Peter

The jewel of the Cotswolds.

Claude Arkell.

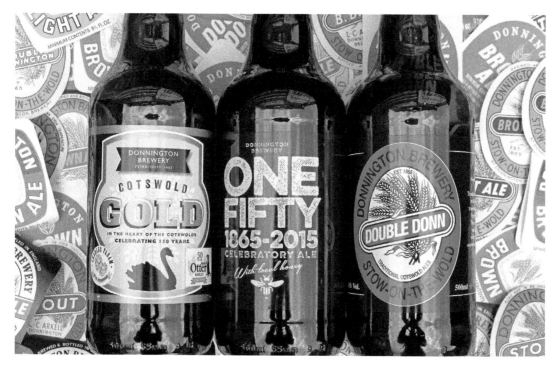

Donnington beer.

Arkell has since passed away leaving James as owner and his son, John, now conducts business at Donnington Brewery.

Two of the regular beers, BB and SBA, have their own pedigree having been brewed at the Donnington Brewery for generations. Donnington Gold, recently introduced to the core range, is described as a golden ale with a citrus flavour followed by a rounded malt finish.

An old brewing book was discovered in May 2011 that detailed the very first brew that Richard Arkell made on 27 May 1865. The replicated beer was called Founders Ale and was very similar to a contemporary golden beer. The finest Maris Otter malt was used, and the beer was an instant success. There have been other occasional brews, including a luscious stout called Black Swan and a beer called Life Sentence that was bittered with Admiral hops. Diamond Queen was bottled in 2012 for the Queen's Diamond Jubilee year. A celebratory beer made with local honey brewed for the sesquicentennial year was called appropriately One-Fifty.

The twenty-first century has also seen the acquisition of three new pubs – the Pheasant Inn at Toddington, the White Bear at Shipton on Stour in Warwickshire and the Red Lion at Castle Eaton in Wiltshire. After 150 years of trading, the Donnington Brewery remains true to its core values of tradition.

Stroud Brewery

Peter Leversage, a farmer of Middle Lypiatt, with his associates Mr Grazebrook and Mr Burgh, established the Stroud Brewery in about the year 1760. After the retirement of Messrs Grazebrook and Burgh, Mr Leversage took Mr Joseph Watts into the business and for fourteen years traded under the name of Leversage and Watts. Joseph Watts took on a managerial role during this time and was a very successful businessman. In 1819, he became sole proprietor and ably conducted the business for a further thirty-six years. When Joseph Watts died, aged eighty-four, at Stratford

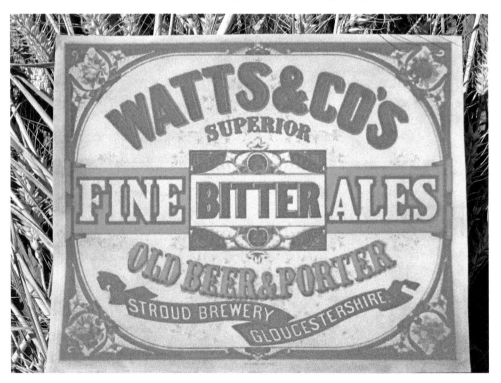

Early days of the Stroud Brewery.

House on 17 October 1855, he bequeathed the Stroud Brewery and Estate to one of his grandsons, Joseph Watts Hallewell. The brewery was then carried on by the partnership firm of Messrs Watts Hallewell, Biddell and Stanton.

The Stroud Brewery was substantially remodelled in 1895. The late Victorian/Early Edwardian period was also a time of transition for the company, and in 1897, the Forwood Brewery (George Playne & Sons) in Minchinhampton was acquired with thirty public houses. This was hardly a hostile takeover as owner Edward Playne immediately took his seat on the Directorate at Stroud Brewery.

Stroud Brewery had secured a branch store in Cheltenham by the winter of 1905 where 'sparkling ales and nourishing stout, especially adapted for household consumption' were available. The premises in Warwick Place, off Winchcombe Street, was previously home to the Anchor Brewery, which had been offered for auction with two public houses in July 1891 due to the bankruptcy of proprietor J. L. Righton.

An advertisement in 1907 drew attention to the quality of the brewing malt produced in their three malthouses:

> Great care being taken in this department to ensure the production of first class malts from which to brew the finest quality beers and stout, for which this Company is so justly celebrated throughout the West of England. It is interesting to note that large quantities of the barleys are purchased from the farmers locally.

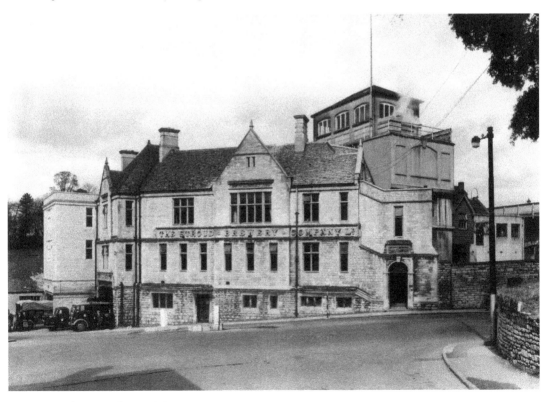

Now the site of Ecotricity.

The old Anchor Brewery was the Stroud Brewery depot in Cheltenham.

A fine sentiment but a bad barley crop that year necessitated purchasing foreign barley, and the members at the 1908 Stroud Brewery AGM were also informed that although hops were cheaper they were not as good when prices were higher.

It is tempting to assume that beers brewed before the outbreak of the First World War were of excellent quality, sourced from the finest ingredients and served in good condition in the pub. This, however, is not necessarily so. Stroud Brewery Chairman, Mr Maynard Willoughby Colchester-Wemyss, explained in 1910 that, 'only in about one harvest in ten or twenty did English barley contain to the full the peculiar virtue given to it by the sun, which was present in foreign barleys, and therefore the addition of a little sugar was necessary to make up for this deficiency'. Brewing sugars can be perfectly acceptable if used in moderation, but 'full-mash' brews without additional sugars usually create better beers. His observation that the English taste of beer had changed and a certain amount of sugar must be used and reinforced with his assumption that English barley was in competition with foreign and that 'the use of sugar was distinctly beneficial to English farmers and in no way detrimental to them' seems to indicate that the policy of the Stroud Brewery was to use cheaper adjuncts in their brews rather than brew exclusively with more expensive brewing malt.

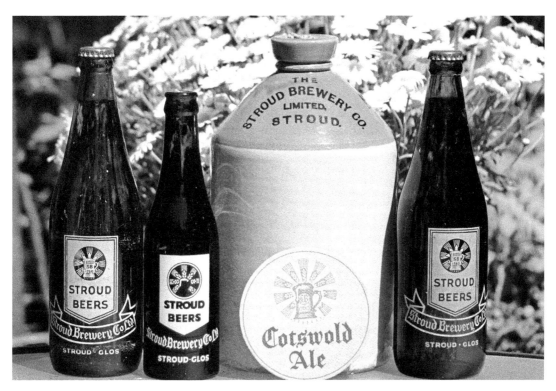

Above: Bottles and jug.

Right: A welcoming sign.

In 1911, Stroud Brewery purchased two 'Halford' lorries that were chain driven with solid tyres, with two paraffin side lights and one acetylene headlamp. Hardly luxurious, but these early lorries did enable the brewery to extend their trading area. Mr J. D. Wilson, the head brewer at the Stroud Brewery, died in a tragic motor accident on 27 October 1928. By a cruel irony of fate, a motor lorry belonging to the Stroud Brewery Co. skidded in London Road and passed over him.

The expansion of the trading area and the consequent acquisition of pubs were possible because of the introduction of motorised transport. Luce's Malmesbury Brewery was bought in 1912. Stroud Brewery then purchased the business of Messrs N. and W. Cook at Tetbury together with their thirty-three licensed houses of which they obtained possession on 30 September 1913.

The most significant acquisition was the purchase of rival Godsell & Sons brewery just to the north of Stroud at Salmon Springs on 25 March 1928. This was not a hostile takeover as there were 'keen buyers and sellers on both sides' Thomas Godsell is thought to have converted his flour mill at Salmon Springs into a brewery in 1850. He was joined in the business by his sons George and James in 1876 and was registered as Godsell & Sons Ltd in 1905. A lengthy article in a publication called 'Where to Buy – Stroud's Premier Shops' (1909) gave a contemporary account of Godsell's brewery. In possibly the most convoluted and highfaluting Edwardian phraseology, we are told by way of introduction in no less than ninety words that, in essence, Godsell's brewed a damn good pint. Godsell & Sons acquired the business of William Sadler Hall of the Cranham Brewery in 1904 for £13,800 with eight pubs, including the Royal William, the Cross Hands at nearby Brockworth and the Crown and Cushion, Five Alls, Gladstone Arms and Sandford Inn, all in Cheltenham.

Let's hope it doesn't rain.

Whitbread signs once covered all this up.

The Tetbury brewery had pubs in Gloucestershire and Wiltshire.

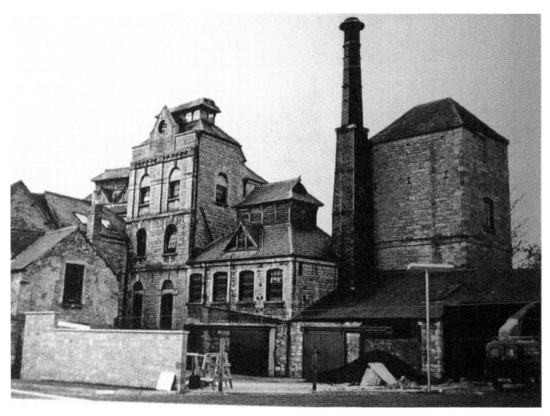

The old brewery is now prestigious residential development.

A sign at the Adam & Eve in Paradise read God Sells Ales.

Above: The old Salmon Springs offices.

Right: Wellington Arms in Gloucester, now closed.

Godsell & Sons also had a branch at 9, Bell Lane, Gloucester. From this establishment, Godsell's A1 Strong Ale could be purchased at 1s 8d a gallon in 1902, and their AK was a bargain at 1s per gallon. At the Stroud Brewery Shareholders meeting in December 1928, the chairman summarised that it was the wish [of Godsell's] to keep their own brewery with its up-to-date machinery in full working capacity but the directors 'did regret that under the circumstances the brewery at Salmon Springs had to be closed'. Maj. Kenneth B. Godsell was immediately appointed on the board of directors at Stroud Brewery.

In 1931, Stroud Brewery acquired the long-established business of Warn & Sons of Tetbury. John Warn was licensee of the Horse and Collar Inn, Church Street, Tetbury in 1820 and probably brewed on-site. Upon his death, the business was carried on by his wife Mary Warn, and by 1876, the family were brewing at the Barton Steam Brewery in Church Street with William Warn at the helm. William married Eliza Witchell whose family ran the rival Witchell's Dolphin Brewery (founded *c.* 1820), which was also located in Church Street. In 1903, Witchell's Brewery was acquired by Warn & Sons. Warn's Oatmeal Stout was highly regarded and gained medals at the prestigious Brewers' Exhibition in London. The business suffered during the upheaval of the First World War and an attempt to invest capital into the ailing brewery in December 1927 by registering as a private company seems to have failed as it was voluntarily wound up in June 1931.

It is generally thought that traditional cask beer fell out of favour in the 1960s with the introduction of keg beer that guaranteed a sparkling clear pint. However, as early as 1925, the shareholders' meeting at Stroud Brewery was being told of an increasing preference for bottled beer 'otherwise than naturally conditioned'. It was

An early style of golden ale.

announced that arrangements had been made for the installation of a complete chilling and carbonating plant that was necessary for modern requirements. One year later the shareholders were told,

> Previously the beer was bottled and kept until it was matured, but now it was chilled and aerated by a special process. The sales of bottled beer had increased very largely, and the advantage of the new plant which had been installed was that directly it was bottled it was fit to drink, being brilliant in colour, and could be drunk to the last drop.

The operations of the Stroud Brewery during the Second World War and the austerity years that followed were severely affected by shortage of labour, restrictions on the availability of raw materials, a substantial increase in beer tax and a decline in the strength of beer. At the Stroud Brewery AGM in December 1944, it was noted that the lack of manpower had compelled the company to close one of its maltings, and concerns were expressed that the requirements for sending beer to the troops abroad would reduce the supplies of beer available for customers. The company launched an in-house magazine called the *Stroud Brewery Courier*, and it was noted in the March 1947 edition that the coal stocks at the brewery had been severely reduced necessitating the reduction of beer output by a third. Raw materials for brewing were also in short supply. From 1 January 1948, the government restricted the supply of brewing sugars prompting this remark in the Stroud Brewery Courier: 'It is gratifying to know that "Stroud Beers" are so popular, but it is regretted that supplies are not sufficient to meet the demand. No Stroud house appears to have sufficient supplies to open the

The White Hart, Cinderford.

full number of hours.' Despite all these difficulties the brewery managed to maintain production.

The situation had greatly improved two years later when the quality of Stroud Beer was described as being excellent during the Easter holidays of 1949, a time when the price of a pint was 1*s*. The company had also introduced new point-of-sale material featuring the 'tankard' as the trademark of the Stroud Brewery. A new beer called Cotswold Ale was launched in December 1949, sold in public bars for 1*s* 4*d* a pint. The popularity of Cotswold Ale, particularly in bottles, led to the introduction of Cotswold Stout in December 1952. To celebrate the Coronation of Queen Elizabeth II in 1953, the Stroud Brewery brewed a special Coronation Ale and decorated the brewery in Rowcroft with a large colourful tableau, which was illuminated at night.

Col W. H. Whitbread was on the Directorate of both the Stroud Brewery Co. and Cheltenham and Hereford Breweries Ltd, and under his aegis, supported wholeheartedly by the board of directors, the decision was taken in 1958 to merge the two companies to form West Country Brewery Holdings Ltd. Col Whitbread wrote, 'And so it is that two hundred years after their separate foundation these two companies find it

Various designs for Allbright beer.

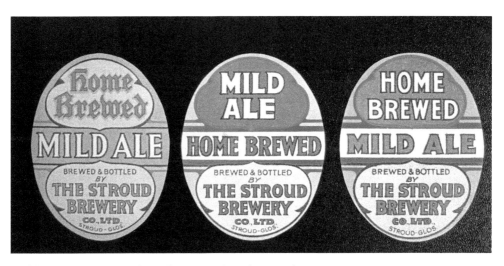

Mild was never a popular Gloucestershire beer style.

advisable to complete no longer but to combine and exchange their goods and expertise and experience and re-equip their breweries and houses to meet modern conditions together.' Eight years later, the Stroud Brewery had ceased brewing, and their brands had been transferred to the Cheltenham Brewery. The Stroud Brewery at Rowcroft was demolished in the winter of 1973. The site of the brewery remained derelict until building work commenced in July 1989 on the £5.1 million headquarters of the Stroud and Swindon Building Society. The site is now occupied by Ecotricity.

Cheltenham Brewery – Down the Gardner's Path

John Gardner, a banker by profession, founded his brewery in Cheltenham's High Street in 1760 when the prosperity of the town was in its infancy. When he died, the brewery was left to his brother-in-law, James Agg, a retired military engineer who changed his name to James Agg-Gardner to perpetuate the name of Gardner's Brewery. Succeeded by his son James Tynte Agg-Gardner, the brewery went from strength to strength. James T. Agg-Gardner was also Cheltenham's MP and was very popular gaining large majorities at general elections. It was noted that, 'despite the persistent calls upon his time and energy that his Municipal and Parliamentary duties must necessarily entail he has carried on most ably the tradition built up by his ancestors of sending out from

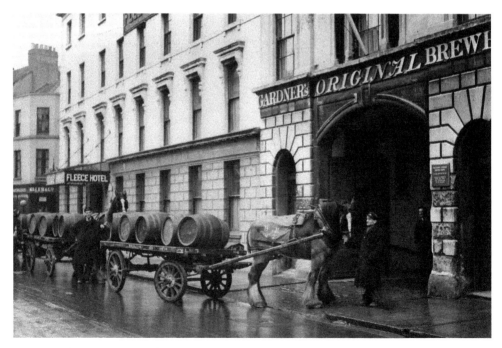

Guinness being delivered by horse and dray.

the brewery at Cheltenham to the public of Gloucestershire beers that have met with undoubted popularity'. To facilitate further growth, the brewery was registered as a limited company in 1888 and became known as the Cheltenham Original Brewery. The prospectus for share allocation described the business as one of the largest in the West of England with a modern thirty-five quarter brewery plant, with a secondary plant capable of working fifteen quarters. There were 153 hotels and public houses tied to the brewery for trade. In 1897, just nine years after becoming a limited company, the brewery suffered a devastating fire that destroyed all the main buildings. The fire was a serious setback but rebuilding took place quickly and skilfully to accommodate a new and up-to-date brewery, 'one of the most excellently equipped in England', which started brewing just a year later. As if to celebrate the achievement in 1897, the Cheltenham Original Brewery acquired the family business of Stibbs & Co.'s Albion Steam Brewery in Cheltenham and their tied-houses that included the Hatherley Inn in the town and the Royal Oak in Andoversford. The Nailsworth Brewery was amalgamated with the Cheltenham Brewery in 1908 and further acquisitions followed at a rapid rate during the First World War and throughout the inter-war years.

Nailsworth Brewery was founded by Joseph and Samuel Clissold in the early nineteenth century. Samuel died in 1842, and the business was successfully carried on by his son Joseph Clissold. Joseph was later joined by his sons William and Joseph to trade under the family name Clissold & Sons and during their tenure the brewery was

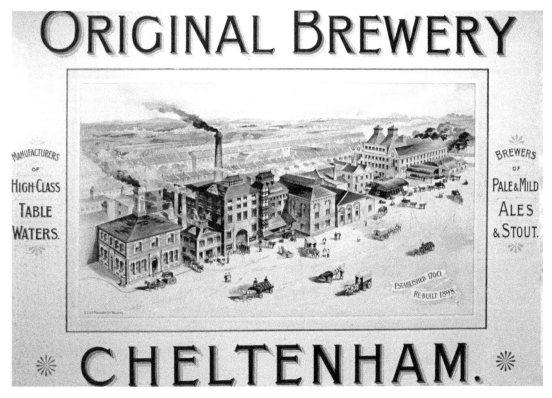

When bottled waters were high class.

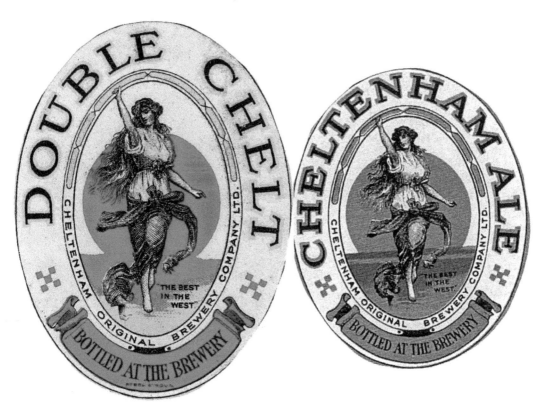

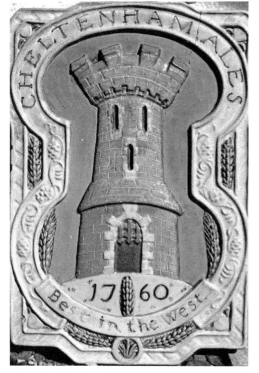

Above: Early use of 'Best in the West' slogan.

Left: Introducing the Castle.

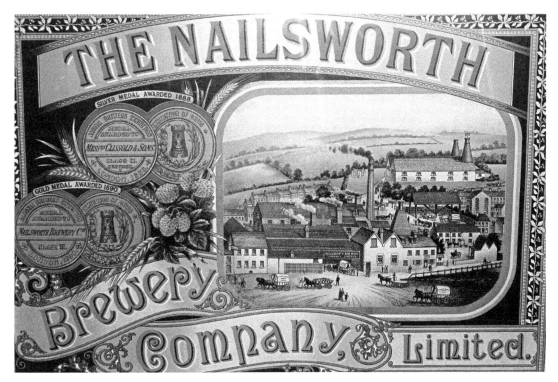

Gold medal awarded in 1890.

substantially rebuilt and many improvements made. The Eagle Brewery at Bowbridge was acquired in 1897, a business operated by Alan Neame who immediately took on a directorship at the Nailsworth Brewery. Alan Neame was born in Faversham, Kent around 1858 and was related to the family associated with the Shepherd Neame brewery. By 1892, he was in partnership with a Messrs Holmes and Harper and brewing at the Church Street Brewery in Stroud. When the company was dissolved, he set up his own business at Bowbridge, but this enterprise appears to have been short-lived.

In August 1889, the business was registered as the Nailsworth Brewery Co. with the Clissold family still in control. Alfred Barnard in his work *Noted Breweries of Great Britain and Northern Ireland* remarked,

> We found the bitter ale simply delicious, full of life, well flavoured with hops, and for brightness and condition quite up to the standard of the London and Burton ales. We sampled the extra stout, which we found to be a rich drink, full of body, and of highly nutritious qualities. Of the bottled pale ale and porters we can also speak in unqualified terms of praise, as they are quite up to and as good as any turned out by the London bottling houses.

An advertisement for Clissold & Sons Prize Medal Ales and the Celebrated Nailsworth Stout gave notice that casks could be supplied from 5 to 108 gallons!

Have you seen the size of those casks?

The fortunes of the Nailsworth Brewery were beginning to decline at the start of the twentieth century. The opportunist Stroud Brewery conducted a detailed survey of the failing business with a view of possible takeover in 1905 and found that although profits were down the balance sheets were still in credit. However, a study noted that the public houses were in a very bad state of neglect and concluded that, 'The future profits of Stroud Brewery will suffer diminution by heavy repairs although it may be politic to make some sacrifice to prevent the business from being acquired by a near neighbour.' In May 1908, a meeting was held in the offices of the Cheltenham Original Brewery to discuss a proposed amalgamation with the two companies and the deal was signed. Brewing at Nailsworth ceased and, much to the consternation of the Stroud Brewery, Cheltenham Brewery gained a foothold in the Stroud Valleys.

Beman, Charles and Fletcher of Victoria Brewery, Stow on the Wold, were advertising their strong XXX ale for 1*s* 6*d* per gallon in 1841, which 'was guaranteed to be made from malts and hops alone'. Their Double Stout Porter was also said to be of similar purity, singularly rich and fine flavoured. They also offered a table beer at 6*d* per gallon. The Victoria Brewery was in the ownership of Richard Gillett and his nephew William by 1861, although it was withdrawn from sale in an 1879 auction when bidding stopped at £4,800. The business was subsequently acquired by Edwin Augustus 'Gussy' Green. When Cheltenham Original Brewery took over the brewery in 1914, there were sixteen pubs in the estate. The brewery offices are extant.

The restrictions imposed on the licensed trade during the First World War had significant repercussions on small family brewers, permitted pub opening hours were curtailed and the beer duty per standard barrel rocketed through the war years. The strength of beer also fell dramatically partly due to government directives and shortage of brewing materials. One local brewery that might have succumbed to the economic and political pressure was Tayler's Cotswold Brewery in Northleach. In late Victorian times, Tayler & Co. was a thriving brewery with fifteen pubs mostly located around Northleach. Thomas Tayler died in October 1919, aged fifty-seven. He left £33,736 to his wife Lottie. Cheltenham Original Brewery acquired the business in the same year. The old brewery buildings were converted to residential flats in 1999.

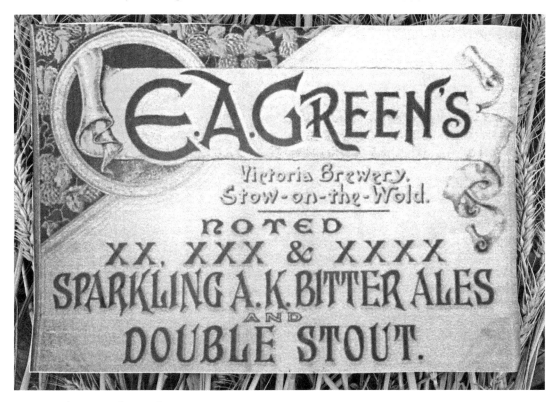

Five beers to choose from.

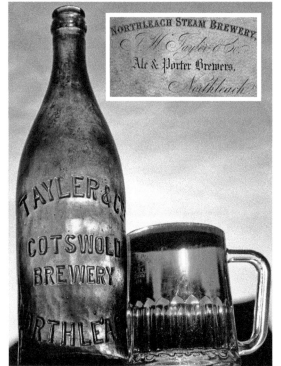

Above: E. A. Green, Brewery Offices.

Left: There was once a Tayler's pub in Cheltenham – the Dove and Rainbow in Burton Street.

The Roman numerals read 1999.

Thomas Arnold established a brewery in Wickwar High Street at the beginning of the nineteenth century. He was succeeded by his three sons who took the family business forward trading as Arnold & Sons. Under their auspices, they constructed a new brewery near Wickwar railway station. By 1876, Thomas Arnold junior, now in the business without his two brothers, had formed a partnership with Thomas Halsey who eventually gained overall control. Mr Halsey invested considerable capital into the brewery passing the business to his two sons and future son-in-law in 1884. The firm of Arnold & Co. Ltd was registered in 1886 to acquire E. and B. Trimmer of Gloucester. Just two years later, the family brewery of Perrett's of Bournstream near Wotton-under-Edge was acquired and to access finance the business was re-registered as Arnold, Perrett & Co. Ltd. There was further growth in 1896 when the Tewkesbury Brewery Co. Ltd was acquired, then operating as J. W. Wilson Original Brewery, but previously trading as Blizzard and Coleman & Co.

Arnold, Perrett & Co. Ltd of Wickwar was absorbed by the Cheltenham Original Brewery in 1924. The old brewing plant was stripped out, and the premises were converted to cider making and trading and became the Wickwar Cider Co, changing to the Gloucestershire Cider Co. in 1931. The storage facilities were considerable, the cellars, sixty feet underground, housed some of the largest reinforced tanks in the

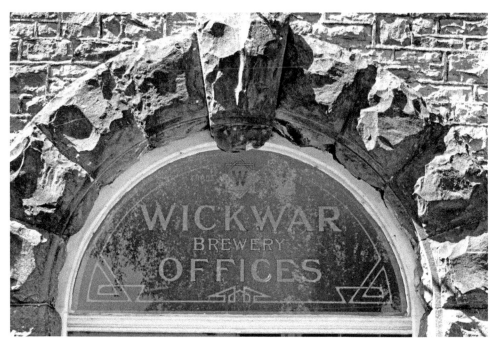

Arnold, Perrett & Co., Wickwar Brewery offices.

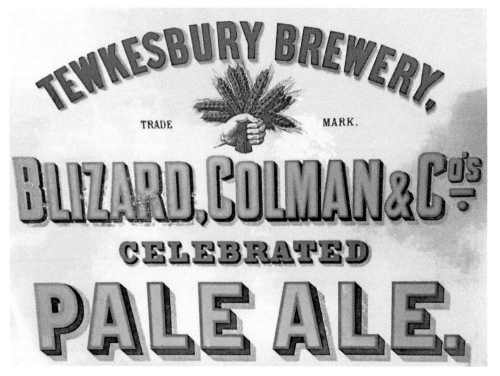

Tewkesbury Brewery owned twelve pubs in the town.

The words 'Blizard & Coleman' are still legible on the building.

country with a total capacity of 1,500,000 gallons. In 1959, H. P. Bulmer & Co. of Hereford acquired a 51 per cent interest in the Gloucestershire Cider Co., and the Wickwar cider factory was closed in 1970. The name of Arnold Perrett was perpetuated into the off-licence division of West Country Breweries. Wickwar Brewing Co. now occupies the premises.

The next brewery to be swallowed up by the expanding Cheltenham Original Brewery was Wintle's Forest Steam Brewery in March 1930. Thomas Wintle had established a brewery in Mitcheldean in 1868. At just thirty-five years of age, this must have been a very bold business venture, no doubt financed by a very generous bank loan. In the same year, Thomas had a son, Francis. The brewery was constructed with red sandstone cut from the Wilderness Quarry. In November 1870, Thomas Wintle wrote to the *Gloucester*

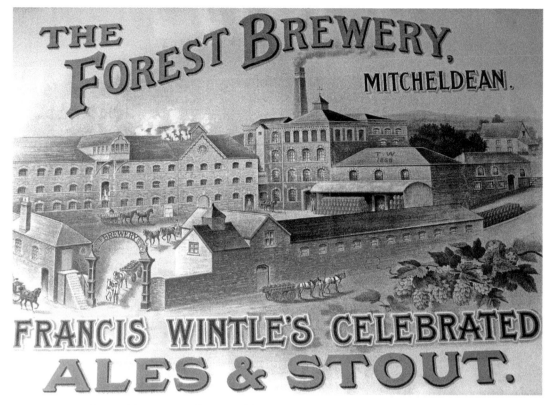

In 1926, the malthouse was destroyed by a devastating fire.

Journal to complain that a report that he had been fined a sum of 150s for adulterating beer at his brewery was 'made by some maliciously disposed person, with a view to the injury of my recently established Brewing Trade and damage to my reputation generally'. Outraged by the false accusations, he offered £1,000 to any charitable institution in the county if any competent analyst could find trace of any ingredients in the 'whole stock of beer on my premises (over 20,000 gallons) if any ingredient other than the legitimate ones can be found'. Thomas died in 1888, aged just fifty-five. After only twenty years in the business, it is questionable whether he saw any financial gain from the brewery. His son, Francis, then took on the running of the brewery. As a young and enthusiastic businessman, he built on the reputation of the Forest Brewery, and in its heyday it supplied between sixty and seventy public houses, many owned by the brewery itself. In March 1923, Francis Wintle put the family business up for auction. By this time, he was suffering from ill health (he eventually died in 1943). A reserve price of £200,000 for the brewery and its seventy-two tied-house was not reached. The failure to sell may be partly attributed to a proviso in the sale that clearly stated that any prospective purchaser had to continue brewing at Mitcheldean for a period of three years, and a restrictive covenant to the value of £10,000 was in place to secure this obligation. After some deliberation, it was decided to sell the business to a Mr K. O. Homfray for £175,000 who promised to maintain the brewery at Mitcheldean thus securing the jobs

of about fifty employees. In September 1923, Mr Homfray became Managing Director, and the brewery continued trading as Wintle's Brewery Co. Ltd. In 1926, the malt house at the brewery was devastated by fire, which was so fierce that the entire top floor of the building was destroyed and had to be demolished. Four years later, it was announced that the Cheltenham Original Brewery had purchased the Forest Brewery for a sum in the region of £250,000. Mr Homfray relinquished his position of Managing Director in March 1930. From the outset, it was obvious that the Cheltenham Original Brewery had purchased the Mitcheldean Brewery with the intention of closing it down. Despite hollow promises of continuing brewing at the old Wintles Brewery, the Cheltenham Brewery closed it down around 1937.

When John Gardner established his modest brewery in Cheltenham High Street in 1760, he could not have possibly envisaged that some 175 years or so later the trade would eventually extend throughout Gloucestershire and into neighbouring counties. No doubt, he would have been impressed with the importance of the Cheltenham Brewery, but whether or not he would have been happy with the loss of its local identity may have been regarded less favourably. In 1945, Cheltenham Original Brewery acquired the Hereford & Tredegar Brewery in Hereford and the name changed to Cheltenham & Hereford Breweries Ltd.

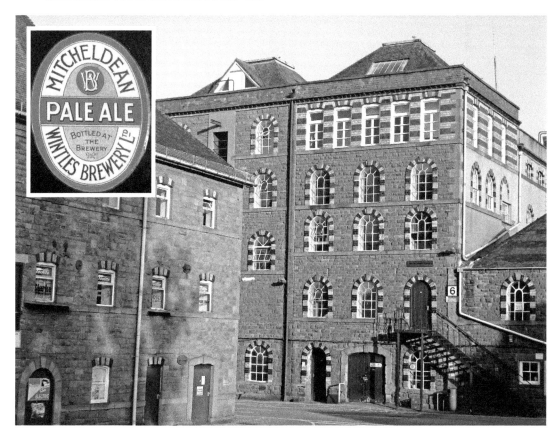

Wintle's had ninety-three licensed premises.

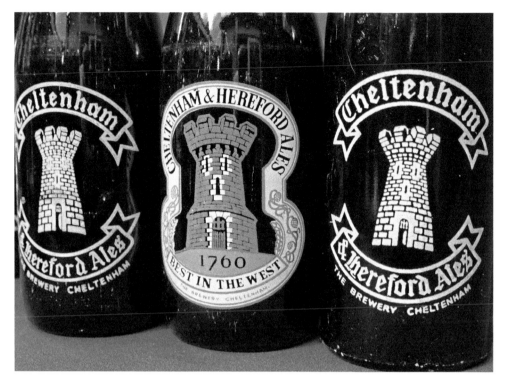

Brewing ceased in Hereford in 1963.

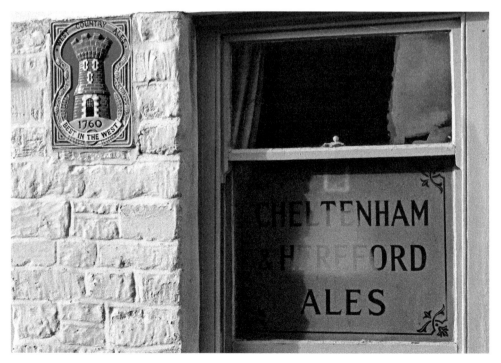

The old Swan Inn, Minchinhampton.

Flowers from the West Country

In the immediate post-war period, the brewing trade had been ravaged, substantial investment was essential to improve and update time-expired brewing equipment and refurbish neglected public houses. Britain's £3 billion debts accrued in the war necessitated high tax, and rationing became part of everyday life. Many regional breweries were struggling and facing an uncertain future, rising property prices prompting some breweries to sell up in order to release their land for lucrative development. Cheltenham & Hereford Breweries were affected by the economic downturn and needed a cash injection. They turned to Whitbread for help.

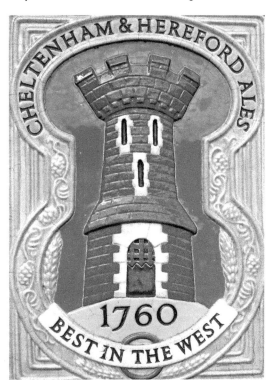

Still *in situ* at the old Foxhill Inn, Guiting Power.

In 1948, more than 200 years after its foundation, Whitbread issued shares to the public through the Stock Exchange. This was initiated by the company's Chairman Col W. H. Whitbread, who had taken office four years previously. 'Colonel' Bill had gained experience in brewing, studied chemistry and, crucially accountancy. The company was in need of massive investment, and the finances required were beyond the reach of the existing shareholders. By becoming a public company, sufficient shares could be raised to safeguard the business and secure future growth while retaining enough shares to maintain ownership. With their own house in order, Whitbread found itself being asked to buy strategic minority shareholdings in regional breweries throughout Britain. The only proviso being that Whitbread beer had to be stocked alongside the breweries' own beer. It was a shrewd business move, benefiting both sides. Stroud Brewery and Cheltenham & Hereford breweries took up the offer and appointed 'Colonel' Bill on their board of directors.

In 1955, Col W. H. Whitbread said,

A well managed company like the Cheltenham & Hereford Breweries has a local tradition and is a human entity with staff and employees who have worked with the company for many years and their fathers and grandfathers in some cases before them; they may also hope that their sons will be employed in the organisation. It seems to me that a company such as this, with all its staff and employees, is of great human

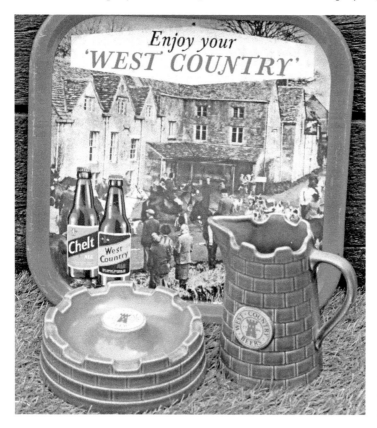

The tray features the Frogmill Inn near Andoversford.

importance and it would not be in the best interests of the brewing industry, or indeed the country, for such an entity to be liquidated for the benefit of a quick profit for purely financial interests ... I am convinced that the continuance of old established concerns run on progressive lines, is in the public interest and consequently sound business.

'Colonel' Bill was respected in the licensed trade not only because of his sound business acumen but also because Whitbread had a good reputation for the quality of its beers, particularly those that had been chilled and filtered and kegged. That may seem surprising today, but when Tankard was launched in 1957, it was well received and prompted Cheltenham and Hereford to duplicate the process by brewing their own Gloster Keg. The Cheltenham Brewery brewed traditional Bitter, Pale and Mild

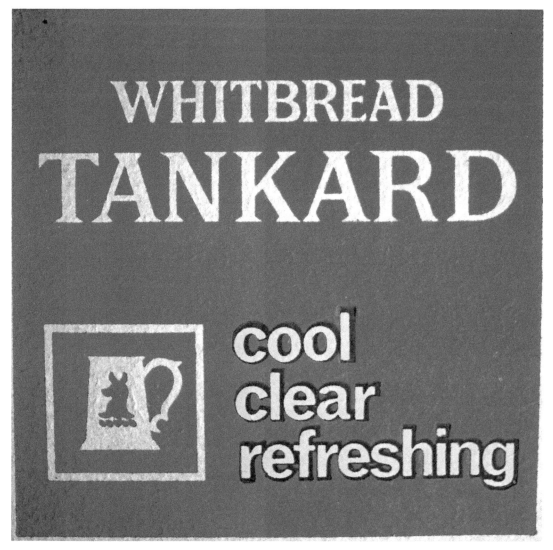

'It's Tankard that helps you excel, after one you'll do anything well.'

ales sent out to the pubs in wooden casks. The quality of these cask-conditioned ales was then entirely dependent on the skill of pub landlords. The beers had to be properly looked after in the cellar and pipes and pumps kept scrupulously clean. The reality was that lazy landlords were often guilty of serving sour and cloudy beer and in some cases pouring the slops back into the cask. Keg beer, on the other hand, was of consistent quality and cold to drink.

Just three years after 'Colonel' Bill had had written in praise of the brewery at Cheltenham, the decision was taken to merge Cheltenham and Hereford with the Stroud Brewery to form West Country Brewery Holdings Ltd. Capital was raised through the Whitbread Investment Co., a scheme where Whitbread would take a large minority shareholding with the acquired business becoming an 'associate'. This investment policy became known as the Whitbread 'umbrella'. A degree of rationalisation took place with all traditional beer production being transferred to Cheltenham, while Gloster Keg and other Whitbread keg beers were manufactured in Stroud. Considerable investment took place with many pubs gaining decorative and distinctive 'Best in the West' ceramic plaques resplendent with the Cheltenham Brewery 'castle' logo. Whitbread officially took over West Country Breweries in 1963, but their 'Best in the West' branding continued only for a few short transitional years ultimately to be replaced by the corporate logo of the national parent company.

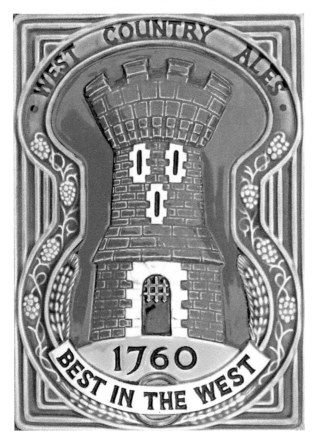

These delightful plaques were manufactured in two sizes.

Tankard (Stroud Brewery) and Castle (Cheltenham Brewery).

A typical West Country Breweries pub at Strensham.

Under the full control of Whitbread, the Cheltenham Brewery became little more than an anonymous processing plant prioritising Trophy keg beer with the traditional Cheltenham ales being brewed as if under a veil of secrecy. The old Stroud Brewery branded beers were quietly discontinued, and Cheltenham bitter and mild disappeared from the portfolio leaving only Whitbread Pale Ale (PA). Trophy bitter was the main brand brewed in Cheltenham and was advertised heavily nationwide. Whitbread PA, which had no promotion, was described without much enthusiasm in the 1976 *CAMRA Good Beer Guide* as being 'bland and unspectacular'. That assessment was probably unfair as when kept well the light bitter was refreshing with a hoppy bite and a pleasant yeasty tang. Yet, familiarity bred contempt and a certain resentment. The 1978 edition of CAMRA's *Real Ale in Gloucestershire*, for example, listed seven pubs in Cinderford that all sold just one beer – Whitbread PA.

Whitbread had fourteen regional breweries in the late 1970s distributed throughout England, each of which maintained their own local identity producing local beers. Whitbread argued that these inherited brews were often an acquired taste and not necessarily palatable or popular away from their traditional trading area. Certainly, bad cellar management resulting in poorly kept beer did not encourage a loyal customer base.

By the advent of the 1980s real ale, championed by CAMRA, enjoyed a healthy revival and a number of new breweries had been established nationwide. Whitbread capitalised on the resurgence of traditional beer by reviving the old name of Flowers. The ersatz Flowers & Sons branding on the Cheltenham Brewery actually belonged to the Stratford on Avon Flowers Brewery that was closed by Whitbread in 1968. Flowers Original Bitter was reported to have been based on a recipe from the former

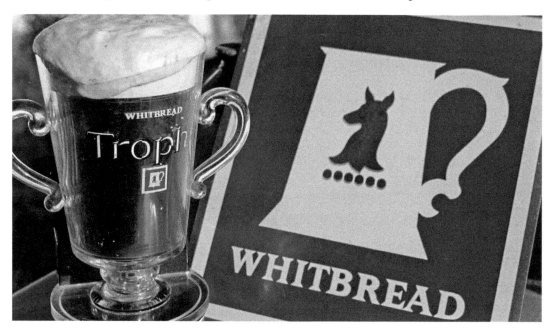

Trophy – the pint that thinks it's a quart.

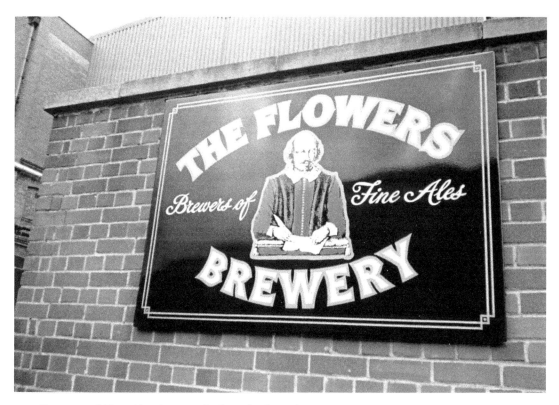

Brewers of Fine Ales, but not in Stratford-on-Avon.

Stratford-on-Avon brewery. Quite what William Shakespeare, the prominent character in the revised logo, would have thought of the move to Cheltenham from his home in Stratford-on-Avon is open to conjecture.

The long-established Brickwood's Brewery at Portsmouth was closed by Whitbread in September 1983, and the two cask beers, Pompey Royal and Strong Country Bitter (itself moved from Romsey to Portsmouth in 1981) were transferred to Cheltenham. Managing Director Charles Flower said, 'We will be spending a lot of time and trouble to make sure that the brew is of the same excellent quality.' The Portsmouth and East Hants branch of CAMRA were less convinced, claiming that there must be some doubt as to whether the beers could be produced to the same taste coming from a brewery 100 miles away. Behind the rhetoric was the fact that Cheltenham had ample brewing capacity to accommodate the interloping beers. The improved facilities for cask racking proved advantageous for the resident Cheltenham beer, now branded as West Country Pale Ale, which was offered to pubs exclusively as a real ale to be dispensed only by hand pump. The absorption of the ex-Portsmouth brews into the Cheltenham portfolio effectively secured the future of the brewery prompting head brewer John Smith to say, 'I'm only glad it wasn't us who were closed down.'

Thomas Wethered & Sons Ltd was a much-loved local brewery founded in the eighteenth century in Marlow, Buckinghamshire. Even though they were acquired by Strongs of Romsey in 1949 and later fell into Whitbread ownership, Wethered's

A decent range of traditional ales.

View from top of the office block. (*Gloucestershire Echo*)

Sign of the Brewery Tap, previously
the Game Cock.

somehow managed to retain their identity and brewed distinctive local beers right up
to the end in 1988. When production was transferred to Cheltenham, it was observed
from a CAMRA member in the Thames Valley that the new Wethered's had a 'manky
sickly taste that bore no resemblance to the old brew'. Just four years later, the new
Managing Director of Whitbread Brewing Co., Miles Templeman, admitted that the
closure policy might had been a mistake:

> We were not as sensitive to the needs of local cask beers as we should have been.
> I think we have been sensitive about the products but such beers have a lot of image
> and perception attached to them which they lose if they leave their original breweries.
> We really have to try to make Wethered's special again. I think we've lost preciousness
> in some of our beers and we need to work at it.

In response, the production of Wethered's Bitter was moved to the McMullen brewery
in Hertford. In the same interview, Mr Templeman emphasised the commitment to
brewing Boddingtons beer at Strangeways in Manchester: 'Boddingtons is a very
precious animal and maybe we've learnt the hard way about how precious a cask beer
can be.'

In August 1993, a beer called Summer Ale was launched by the Flowers Brewery.
This was significant as the beer was brewed exclusively by the Cheltenham Brewery,
finally giving the head brewer a chance to experiment with exciting ingredients rather
than replicate beers from the standard core range. Summer Ale used an equal mix
of crushed pale malt and lager malts with continental Saaz hops used for bittering.

Whitbread even introduced a chain of Hogshead pubs throughout the country that specialised in real ales from micro-breweries and established regional breweries. There was even a Classic Ales series that featured one-off single variety hop brews. At long last the Cheltenham Brewery had discovered an identity. Frazer Thompson, Director of the Whitbread Beer Co., succinctly said, 'We've put the passion back into brewing. We've got happy smiling brewers producing great beer.'

An inevitable consequence of the introduction of exciting and tasty beers within the Whitbread range was the resultant lack of demand for beers like West Country Pale Ale. In the early spring of 1997, it was announced that brewing PA was no longer economic and production would cease. Then the bubble burst with rumours circulating in 1998 that Whitbread were planning to close their regional breweries in Castle Eden in Durham and Cheltenham. The official announcement of closure was made in March with the information that the beer brands brewed at those breweries would be transferred to the Boddingtons Brewery in Manchester that was now running below capacity. The Cheltenham site was put up for sale in an undisclosed figure in excess of £1 million. Miles Templeman's passionate and sincere endorsement of Whitbread's regional breweries of 1992 had given way to the harsh reality of economics and rationalisation within the company. Brewing ceased at Boddingtons in February 2005, and the Strangeways Brewery was demolished in 2007.

More than 230 years of brewing history in Cheltenham came to an end on 19 August 1998 when the last batch of Flowers Indian Pale Ale (IPA) was brewed. It was announced in October that the prime 1.9 acre town-centre site would become a huge

The optimism of 1995 would not last long.

Faded Flowers.

Boddingtons – sour cream of Manchester.

leisure and shopping complex in a £30 million development scheme with a multiplex cinema, bowling alley, shops and restaurants. Demolition of most of the brewery buildings, including the old seven-storey office block, took place in the summer of 2004, but thankfully the development plans made provision for the retention of the cupola tower and the exterior façade of the old malthouse.

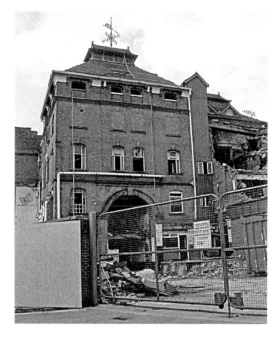

Thankfully, the cupola tower was saved.

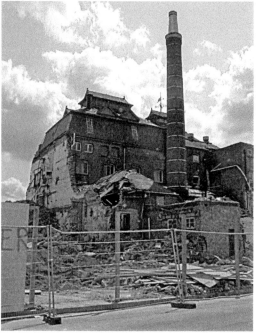

Brewery demolition.

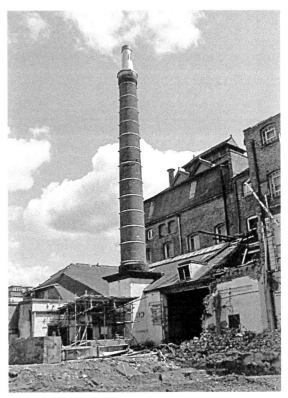

Right: Brewery demolition.

Below: Brewery demolition.

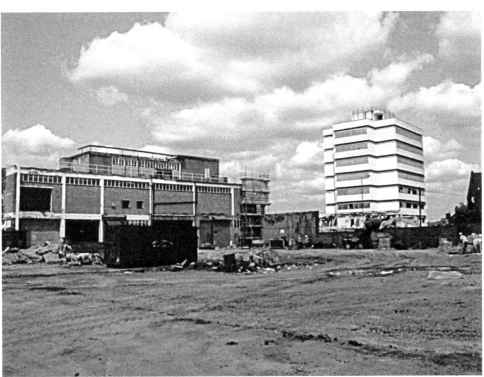

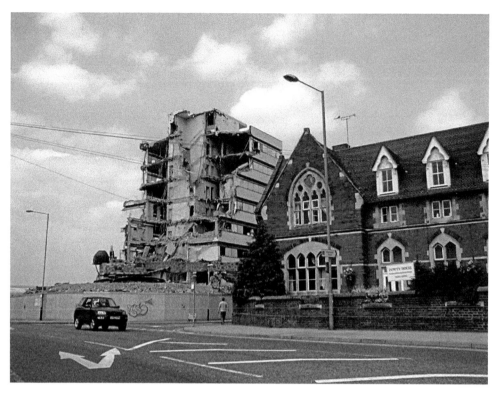

Demolition of the tower block.

A Brewing Renaissance

In October 1978, a small brewery was installed in a converted store room at the Norfolk House Hotel in Bristol Road, Gloucester. Landlord Bob Readdie with his partner David Brown assembled the brewing plant from various sources, including scrap yards. Claude Arkell of the Donnington Brewery gave helpful advice and supplied yeast to the Hawthorne Brewery. After an encouraging start, the quality of the beers began to suffer in the summer of 1979, and Hawthorne ceased brewing for a while. Undaunted, Bob extended the brewery at the Norfolk House Hotel

Brewed in 1980 for the Queen Mother.

GLOUCESTER BITTER Average O.G. 1038

Left: There was also a short-lived Hawthorn Brewery in Cinderford.

Below: For sale at the brewery for 55 pence a pint in 1983.

to produce 200 instead of 60 gallon brews, and by the spring of 1983, Bob was producing a new range of beers, Glevum Mild, Gloucester Bitter and Severnside Stunner Strong Ale. The Hawthorne Brewery ceased trading later in 1983.

The revival in brewing in Gloucestershire continued in May 1983 with the establishment of the Cirencester Brewing Co. in the premises now known as the Brewery Arts Centre. This was significant as the brewery was located in the old cellars of the original Cirencester Brewery that closed in 1937. Unfortunately, the venture did not last long. Two other breweries were launched and indeed floundered during this time – the College Brewery based at the Co-op Industrial Estate in India Road Gloucester, and the Three Counties Brewery in Quedgeley.

The launch of the Uley Brewery in March 1985 can be heralded as a turning point and has provided inspiration for all the new breweries that have since followed. In 2015, Uley Brewery celebrated thirty years in business, and their fine ales have always been held in the highest esteem. The Victorian tower brewery, which is situated in the picturesque village of Uley, was built by Samuel Price in 1833 to provide beers to slake the thirsts of the thousands who worked in the Uley and Dursley area. When the industry collapsed in the early 1900s, the brewery closed. In 1984, the brewery site was on the market and might have been turned into a craft centre. Thankfully, Chas Wright had better ideas and restored the brewery to a going concern. Uley Bitter was the first beer to be brewed and, with an original gravity of 1040, it became affectionately known as UB40. Chas was asked to provide a one-off Strong Ale for the 1985 Frocester Beer Festival, which he called Old Spot Ale. A few casks were sent down to the Great Western Beer Festival in Bristol and, to his surprise, it was proclaimed Beer of the Festival. The consequent demand for Old Spot Ale has meant that it has been brewed ever since. Other beers in the portfolio include Hogshead Cotswold Pale, Laurie Lee's Bitter, Pigs Ear Strong Beer and Old Ric. The latter is the house beer of the Old Spot Inn in Dursley (the CAMRA National Pub of the Year 2008) and is a fitting memorial to Ric Sainty, the legendary landlord and long-time friend of Chas, who passed away in July 2008. Chas Wright and his team at Uley Brewery are brewing to capacity and quite rightly put quality first. As Chas remarked, 'We could brew the best beer in the world, which we do quite often, but it is all cask-conditioned and must be looked after by real publicans.'

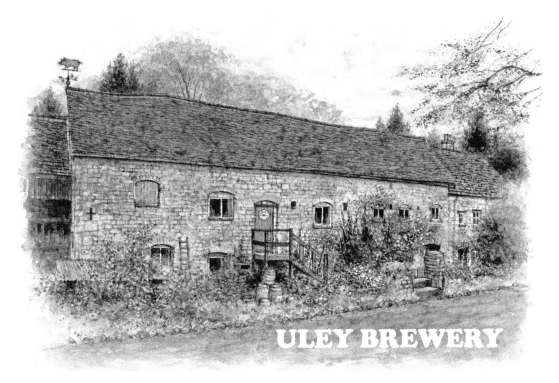

First established by Samuel Price in 1833.

The venerable Chas Wright.

The Wickwar Brewing Co. was set up in the former cooperage of the old Arnold, Perrett & Co. brewery in May 1990 by Ray Penny and Brian Rides, both former Courage brewery tenants. The first beers to be produced in the ten barrel-length brewery were Brand Oak Bitter and Olde Merryford Ale. From the very start, it was Ray's ambition to expand the brewery into the old brewhouse across the road, but it was not until 2003 when the building, which had been used as a bonded warehouse, became available. Even so, it was not until November 2004 when the first brews took place in the original brewery after a £1 million development scheme. The Wickwar Brewing Co. now has a capacity of fifty barrels. An endorsement of the quality of ales brewed at Wickwar came in 2008 when their 6.1 per cent Station Porter, a rich dark ruby brown ale, won the Supreme Champion Winter Beer of Britain 2008 at the CAMRA National Winter Ales Festival. More recently, Station Porter was the CAMRA Champion Beer of Britain, South West Region 2013/14. Under new management, the brewery continues to thrive and now boasts a small chain of pubs.

A new home-brew pub was founded by Geoff Adams in September 1992 at the Farmers Arms in Apperley. This traded as Mayhem's Brewery. Two beers were produced – Odda's Light and Sundowner. When Wadworth Brewery of Devizes bought the Farmers Arms in 1996, it was feared that the home-brew plant would be closed

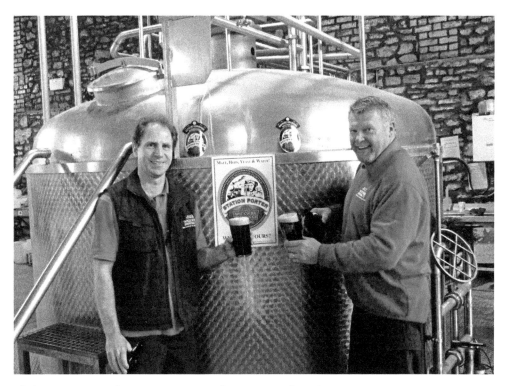

Philip Downes and Ray Penny toast the success of Wickwar Station Porter.

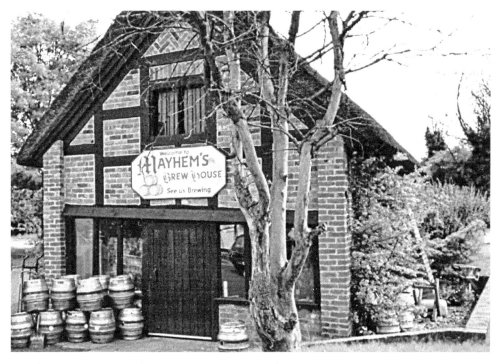

Mayhem's Brewery at the Farmers Arms, Apperley.

but, surprisingly, Wadworth encouraged landlord Geoff Adams to continue brewing and even took some beer to sell in some of their other pubs. However, despite the initial encouragement, the brewery plant was removed in 2001 and reinstalled in their Devizes brewery for specialist and occasional brews.

Freeminer Brewery was set up in industrial premises at Sling near Coleford by Don Burgess and Chris Lewis who had met up when they were both employed as brewers in Manchester. Don had strong family links with the Forest of Dean and was keen to set up a brewery in the area. The first batch of Freeminer Bitter, brewed on a five-barrel plant, was launched in the spring of 1993. The stronger Speculation Ale followed, which was a darker and maltier brew. Because of a lack of free-houses in the Forest, most of the beer was transported to the Manchester area where Freeminer enjoyed a loyal following. Other beers produced at the brewery included Deep Shaft Stout, which was named the CAMRA sponsored *Guardian's* Bottle-Conditioned beer of 1996. Another beer to take on the name of an old Forest of Dean mine was 'Strip& @ It', a lager styled beer, which won the CAMRA Gloucestershire Beer of the Year in 2005. The original premises were found to be too small to cope with increased demand, so in the spring of 2001, Freeminer relocated to Cinderford. Unfortunately, this move coincided with the worst outbreak of Foot and Mouth disease that devastated this part of the country, and

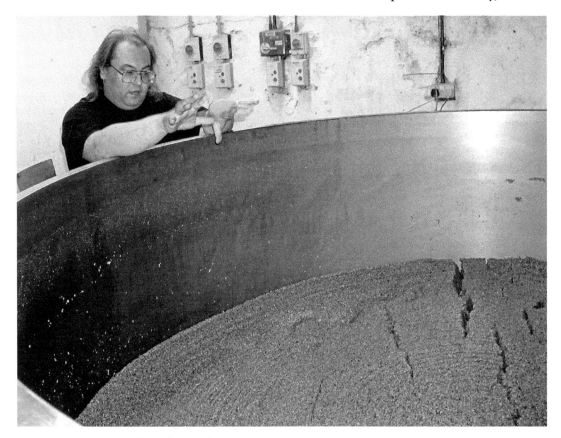

Don Burgess explains the mashing process at Freeminer Brewery.

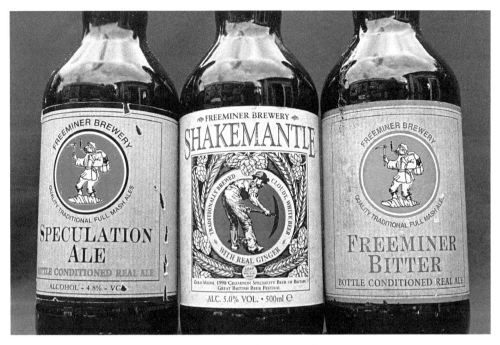

Beers were named after old Forest mines – there was also a Strip & @ It!

hit profits at the brewery. The capacity at the new brewery was forty barrels, enabling Don to brew more beer in one day that was previously possible in two weeks at Sling. In the autumn of 2003, a deal was secured with the Co-op to launch Gold Miner Ale, a bottle-conditioned beer, in their stores nationwide. Another contract was signed with the Co-op in 2005 to produce Bumble Bee 'Fairtrade' Honey Ale using honey imported from Chile. Unfortunately, the Co-op contract soured when profit margins on sales tumbled to the extent that eventually Freeminer were losing money on each bottle sold. A further contract was signed with Morrisons early in 2006 to produce bottled beers in their 'Best' brand. In September 2006, the Freeminer Brewery went into liquidation, but after a cash injection and a change in management the brewery continued to trade. Don was kept on the staff as head brewer. Unfortunately, the change in management failed to save the business and Freeminer closed early in 2016. Don was informed about the decision with a simple text message.

One of the most innovative of the new generation of breweries was established in When Alex Pennycook resurrected the ancient brewhouse within the manor house, which was built during the reign of Elizabeth I, he was mindful of the fact that this would be more than just a labour of love but extremely hard work as the brewery coppers are heated over log fires necessitating very early starts to prepare for the brewing process. The brewery had stood idle since before the First World War, and Alex had to install new brewing vessels. Stanney Bitter, a 'bitter, dry and hoppy beer', was showcased at the 1993 Cotswold Beer Festival. Stanway Brewery is unique as being the only brewery in the United Kingdom to still use log-fired coppers. Occasional beers include Old Eccentric and Lords a' Leaping.

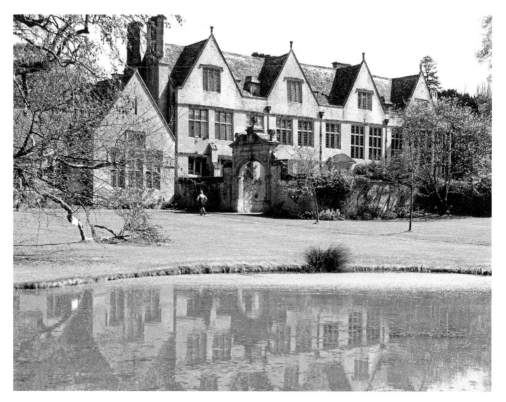

Stanway House.

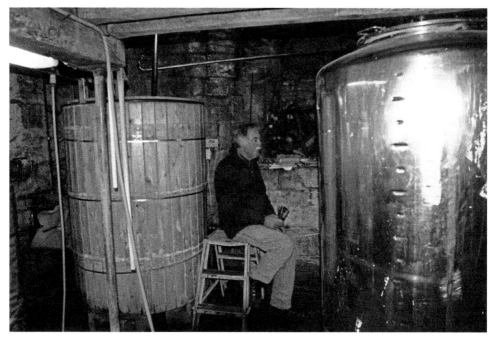

Alex Pennycook, Stanway Brewery.

The idyllic setting of the Stanway Brewery within the honey coloured stone built manor house contrasts starkly with the Isbourne Business Centre near Winchcombe some three miles to the south. This industrial estate is the home of Goffs Brewery, which was established in 1994 by Brian Goff with his son and wife Marcus and Alison. Goffs's regular beers include Jouster, a popular tawny-coloured ale; Tournament, a dark-golden beer; and White Knight, a well-hopped bitter. Black Knight, a full-bodied porter-style beer brewed for the winter period, won Bronze Medal in the 2006 CAMRA Winter Beer of Britain Competition held at the National Winter Ales Festival in Manchester. Occasional and seasonal beers are made in the 'Ales of the Round Table' series that continue the theme of the Arthurian legend.

Dave McCredie set up the Berkeley Brewery in an eighteenth-century barn and old cider cellar at Buckets Hill Farm just to the north of Berkeley in 1994, yet did not brew regularly on the fifteen barrel plant until 1996 . His first beer was Old Friend, a fruity and hoppy brew, and Dicky Pearce, a copper-coloured bitter, was introduced to the portfolio later. Seasonal beers were also brewed, including Early Riser, Late Starter, Lords Prayer and Berkeley Old Ale. Dave ran the brewery almost entirely on his own; his duties covering everything from brewing to delivering the beer. The beers were well received and increasing demand enabled Dave to install another fermenting vessel to bring production up to thirty barrels a week. On Thursday 3 August 2000, Dave was returning home from delivering beer in Wiltshire with two of his sons, Tom and Sam. Dave lost control of the dray near Charlton and hit a tree that trapped him in his seat. Sadly, he died shortly after arriving at Princess Margaret Hospital, Swindon. Miraculously, his two sons survived the tragic accident, sustaining minor injuries. A celebration of his life was held the following October at the Newport Towers Hotel near Berkeley where local brewers donated casks of ale and £820 was raised for his wife Jane and her family.

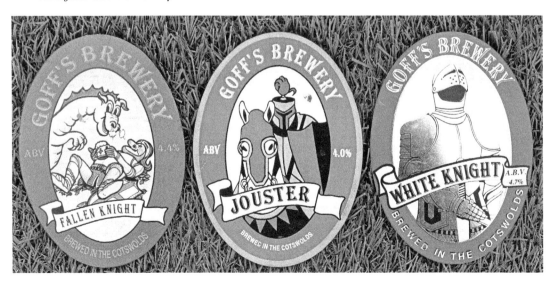

A beer brewed for the birth of Marcus and Alison's daughter was called Sleepless Knight.

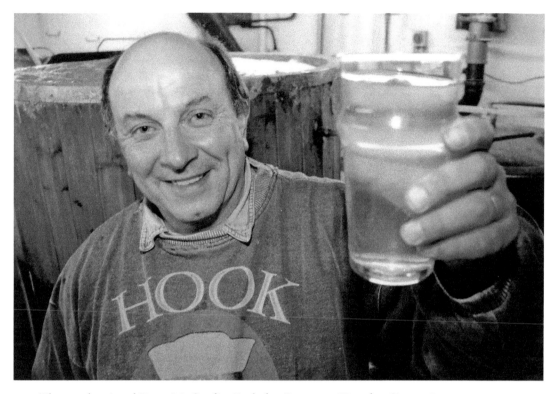

The much-missed Dave McCredie, Berkeley Brewery. (*Dursley Gazette*)

Gloucestershire Beer Has Never Been Better

Whittington's Brewery at the Three Choirs Vineyard between Newent and Dymock was established early in 2003 and took its name from Dick Whittington who was born nearby. The five-barrel brew plant was installed to provide bottled beers for the Three Choirs shop and also to feature in the guided tour of the vineyard where visitors could see the brewing in progress. Cat's Whiskers, a tawny-coloured bitter, was the first beer to be produced by brewer Ben Jennison-Phillips and was also put in casks for distribution to local pubs. It was named Gloucestershire CAMRA Beer of the Year in 2004. Occasional draught beers are still produced, but the emphasis is now on bottled beers.

In the summer of 2005, John Worlock and Warren Bryant, both local businessmen, established the Cotswold Spring Brewery in Dodington Ash near Chipping Sodbury, just over the border in South Gloucestershire. They needed the expertise of a brewer and managed to find Nik Milo who had been working in France but needed little encouragement to come back to join the team at Cotswold Spring. It was an excellent appointment, as when a beer brewed by Nik called CSB Mystery was submitted to the Avon Valley Railway Beer Festival, it scooped Beer of the Festival award! Further success came in 2010 when Old Sodbury Mild (OSM) was declared Gloucestershire CAMRA Beer of the Year, a distinction that was achieved again in 2013 and 2014. The launch of a beer called Gloucestershire's Glory, a golden ale, on 20 July 2007 was ill-timed as it coincided with a day of torrential rain that caused the worst floods in the county's history.

Steve McDonald commenced brewing at Lower Knapp Farm in Woodend Lane, Cam near Dursley in July 2005 in a converted milking parlour, using a five-barrel plant with three fermenting vessels. Trading as Severn Vale Brewing Co., his first brew was Vale Ale, a classic copper bitter. Just a year after starting, Steve was awarded Silver at the Society of Independent Brewers Association Western Region Beer Festival for Dursley Steam Bitter, a summer ale. However, this was eclipsed in 2008 when Severn Sins, a dark stout, gained the accolade of Society of Independent Brewers (SIBA) Supreme Champion in their National Beer Competition. The success was repeated in 2011 when Severn Sins was crowned CAMRA Gloucestershire Beer of the Year. Other superb beers have followed, including Nibley Ale and the delightfully named Luverly Jub'lee, originally brewed to celebrate the Queen's Jubilee. Nik Milo and Steve McDonald

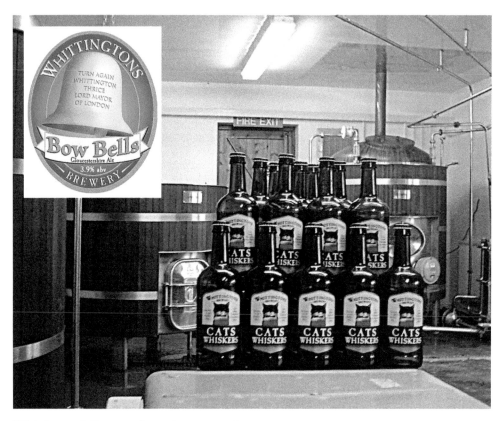

Whittington's Brewery beers have a cat theme.

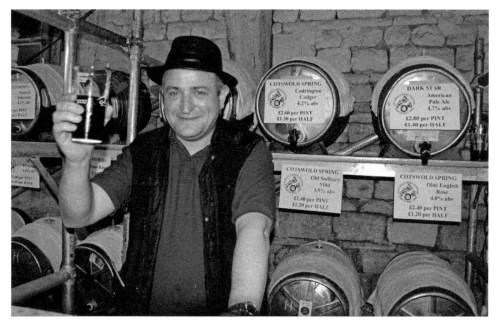

Nik Milo of Cotswold Spring toasts the success of Old Sodbury Mild.

Nik stirring the mash at the Cotswold Spring Brewery.

have recently amalgamated their two businesses to form Combined Brewers and are now based at Tormarton near Wotton-under-Edge. However, the Cotswold Spring and Severn Vale brands continue to be brewed.

The Salutation Inn at Ham near Berkeley was briefly the home of Eagles Bush Brewery, which was installed at the pub in the summer of 2005 by landlord Steve Fisher and his wife Sandra. Five beers were brewed by Steve on a rotational basis with only one Eagles Bushbeer being showcased in the bar at any one time. Sadly because of failing health, Steve's found it difficult to operate the brewery and eventually had retired from the pub. A decade on, however, a new 2.5-barrel-length micro-brewery was installed at the Salutation Inn by landlord Peter Tilley. The Salutation Inn was crowned CAMRA National Pub of the Year in 2015. The new brewery provides an opportunity to brew small-batch beers of varying styles with the attraction of inviting guest brewers who are encouraged to tweak recipes of their own brews.

Roland Elliott-Berry started brewing commercially in September 2005 in a former engineering works in Keynsham Street, just off London Road in Cheltenham. To begin with, three beers were produced – Saxon, Brigand and Turncoat. In November 2006, Roland appointed Ben Jennison-Phillips as head brewer who had previously worked at Whittington's Brewery in Newent. Bottled beers were introduced in 2007 cleverly branded as Cheltenham SPA or Cheltenham Special Pale Ale. Other beers in the Battledown portfolio have included Sunbeam, Tipster, Natural Selection and Four Kings, a 7.2 per cent strong ale.

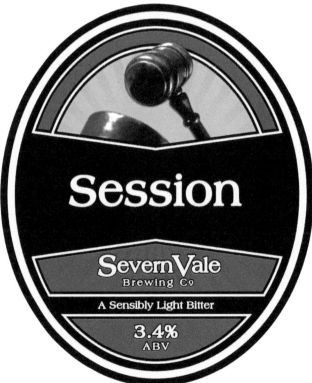

Above: Steve McDonald
pitches the yeast to a brew
at Severn Vale Brewery.

Left: Session – a recreation
of a low gravity 'Boys
Bitter' like West Country
Pale Ale.

Steve Fisher pulls a pint of his home-brew at the Salutation Inn, Ham.

Above: Roland Elliot-Berry and son Felix at the Cheltenham Food and Drink Festival.

Left: A strong ale with a heady aroma.

The first test brew took place at the Nailsworth Brewery on Wednesday 8 February 2006, ninety-seven years after the last brew at the original Nailsworth Brewery. The six barrel-length brewery, located in the basement of the Village Inn, was launched with three regular ales. Jon Kemp looked after the brewing side while Oisin Hawes was responsible for the newly refurbished Village Inn, which opened in December 2006. The exciting redevelopment of a traditional-themed pub with its own brewery nearly floundered when planning permission was initially refused. Oisin won on appeal, but the then Mayor of Nailsworth, one of the key objectors, was less than pleased with the decision that gave Jon the inspiration to brew The Mayor's Bitter. Artists Ale and Dudbridge Donkey were also brewed. Local character and odd-job man at the Village Inn Michael 'Rocky' Holbrow, once a champion table tennis player of Gloucestershire, gained some unexpected attention in 2009 when his name was given to a beer – Old Rocky, a golden ale – that was declared Gloucestershire CAMRA Beer of the Year. Another of Jon's beers, Alestock, won the title of best ordinary bitter in the SIBA West of England and Wales 2009 awards.

Greg Pilley joined the ranks of the new wave of micro-breweries in Gloucestershire when he started brewing in a small unit in the Phoenix Mill industrial estate in Thrupp, near Stroud on 21 May 2006. Choosing the name Stroud Brewery was significant as it heralded the return in name of the town's brewery that had closed over forty years previously. The launching beer was Budding. Edwin Beard Budding invented the lawnmower in 1830, and the machines were manufactured at Phoenix Mill. Just a

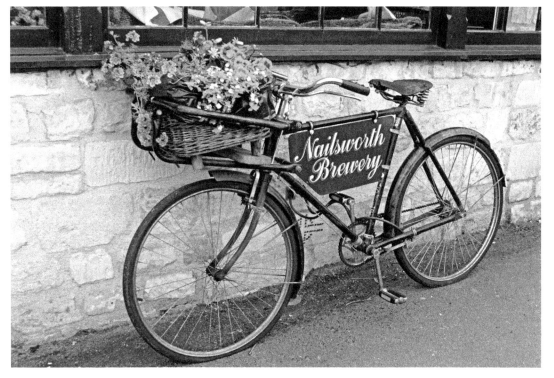

Check your brakes: the steep descent from Amberley to Nailsworth on a pushbike after a few pints is not advisable.

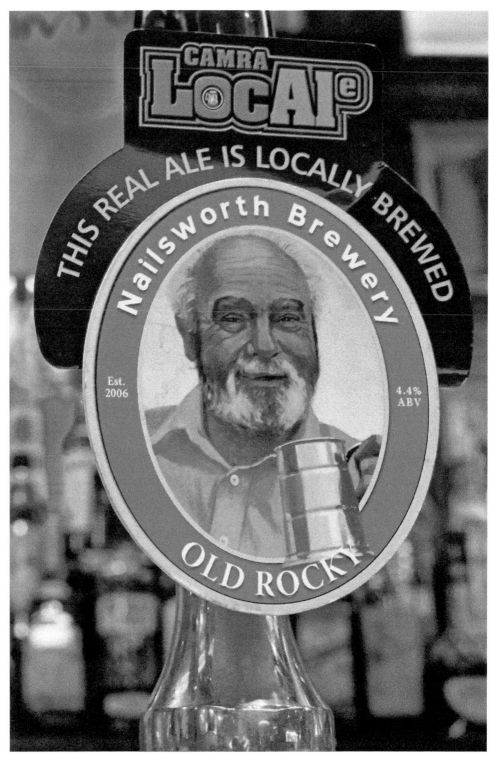

Michael Holbrow AKA Old Rocky – the odd-job man from the Village Inn, Nailsworth.

Jon Kemp of Nailsworth Brewery conducting quality control.

few weeks after starting production at Stroud Brewery, and to Greg's delight, Budding was named Gloucestershire CAMRA Beer of the Year, a distinction that was repeated in 2008. The original five-barrel-length brewery was replaced in 2013 with a plant that quadrupled production. From the outset, Greg has been keen to support local suppliers and chooses brewing malt from Warminster, where Britain's oldest working floor-maltings still use traditional methods unchanged for more than a century. Warminster Maltings use locally grown Cotswold malting barley thus Greg is also sustaining farming in the area. In July 2011, Stroud Brewery scooped Business of the Year in the Stroud Life awards. The core beer range at Stroud Brewery also includes Tom Longand Organic Ale. Other brews have been Teasel, Big Cat, Ding Dong, Five Valleys and Redcoat. Stroud Brewery now boasts its own brewery tap, complete with its own pizza oven, which is open on Thursday, Friday and Saturday.

A second brewery in Cheltenham opened in March 2007. Located in the Kingsditch Trading Estate, the Festival Brewery was the idea of Andy Forbes and Pete Jobson who could see the marketing potential of setting up a brewery with a name that reflected the importance of Cheltenham as a venue for prestigious international festivals – an unlimited scope for themed local beers. The first brew was named Festival Bitter. Andy also produced Festival Gold and Festival Ruby.

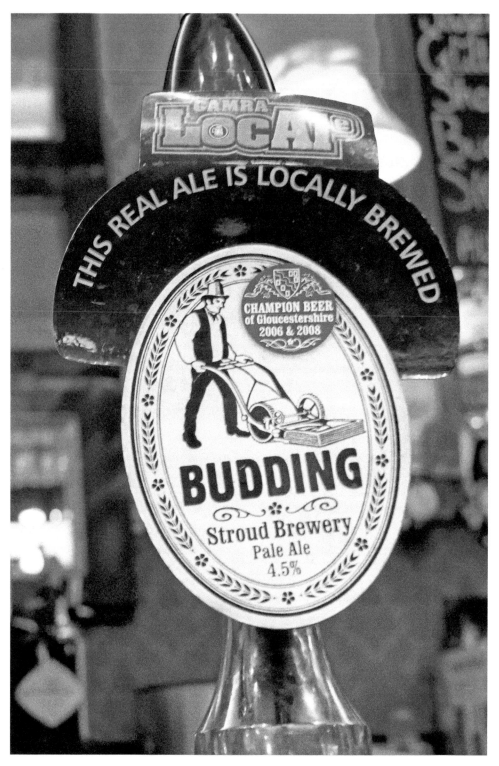

Budding – the inventor of the lawn mower.

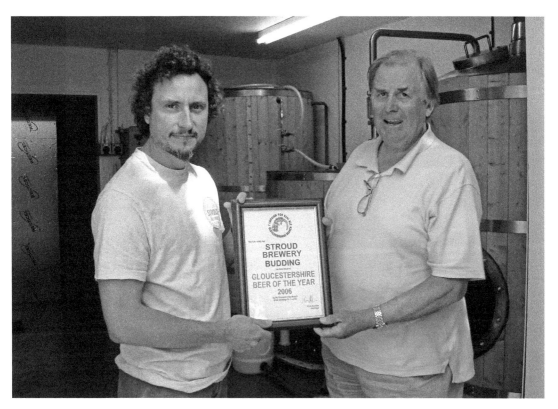

Above: Greg Pilley receives
Gloucestershire Beer of
the Year award from Glos
CAMRA chairman Tony
Aburrow.

Right: Andy Forbes at the
Festival Brewery.

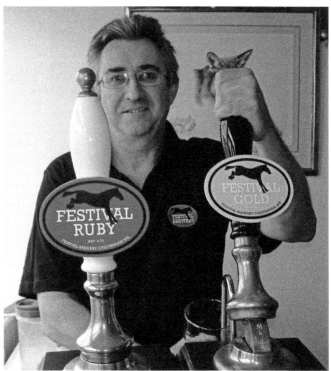

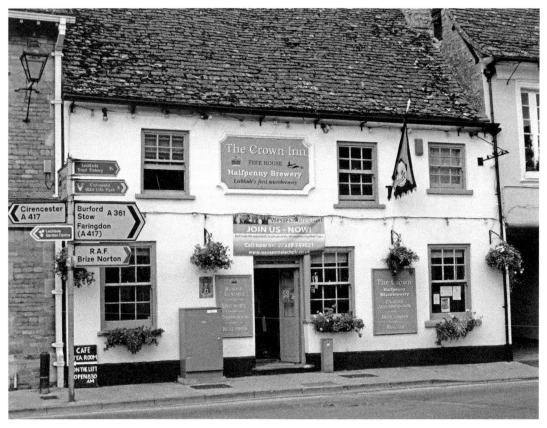

Crown Inn, Lechlade. Home of the Halfpenny Brewery.

The Crown Inn at Lechlade began brewing their home-brewed beer in time for Christmas in 2008. Named after the famous stone bridge that spans the River Thames, the Halfpenny Brewery was set up by the owners of the pub Alan and Valerie Watkins and their brewer Graham Gerrard. Customers at the Crown Inn were asked to think of names of the real ales and came up with Crownin' Glory, Thames Tickler, Old Lech and Crowninnburg!

Prescott Ales opened for business in March 2009 in a 3,200 square feet brewery in Alstone Lane, Cheltenham. The inspiration is derived from the Prescott Hill Climb, run by the Bugatti club, and the names of the beers reflect the motoring heritage of the famous location. Three regular beers are produced: Hill Climb, a light refreshing ale; Track Record, a full-bodied best bitter; and Grand Prix, a full-flavoured ale. Attractive art-deco illustrations of classic motor cars feature on the pump-clips. The range of beers is headed with the apt slogan: 'Great British Lubricants'. Hill Climb won gold medal in the Standard Bitters Category in the 2011 SIBA Wales and West Regional Beer Festival. Increased sales enabled Prescott Ales to expand their brewing plant in 2013, and a year later another beer, Chequered Flag, was introduced to the core range. The latest development is the introduction of Super-6 Craft, where six limited production specialist ales are brewed each year.

Elvis is in the brewery ... but who pinched his guitar?

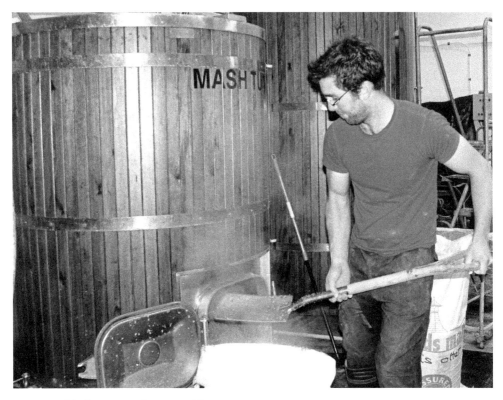

James Bubb, brewer at Prescott Ales.

Prescott Ales – Great British Lubricants.

Tony and Liz Davis moved to Holly Bush Farm on the slopes of May Hill near Longhope in 2007 promising themselves a less-stressful lifestyle after spending time in management training. Tony, a keen home-brewer, was keen to set up a micro-brewery and a move to rural Gloucestershire presented him with such an opportunity. A former dairy building on the farm was partly demolished and reconstructed to house a six barrel-length brewery. After some trial brews, May Hill Brewery was officially launched at the Dick Whittington pub in Gloucester on Friday 18 November 2011. Four core beers were on offer: Admiral May, a traditional bitter; Legend, a pale ale; Legless Cow, an amber-coloured ale, and Summit, a full-flavoured dark malty ale. May Hill Wassail was brewed as a winter ale and a further beer, 'Well Good!', a golden

Tony Davis brewing at May Hill Brewery.

summer ale, later joined the portfolio. In the autumn of 2013, Tony and Liz were joined in an expanded team by Peter and Anne Williamson and their son Paul. Under the control of the Williamson family, with the support of Tony and Liz, the business moved forward and in May 2014 was renamed Hillside Brewery. Legless Cow was retained in the core range and three beers added: Legend of Hillside, a classic English IPA; Pinnacle, a fruity pale ale; and Over the Hill, a malty dark mild. A contract to supply Midcounties Co-operative stores with their bottled beers was agreed in 2015. Exciting plans to convert one of the old cattle sheds to create an on-site bar and cafe for events was recently launched using online crowd funding.

Gloucester Brewery began brewing in November 2011 in a building originally used as stables in the city docks. Partners Jared Brown and Bev Booth, with the assistance of Tony Hier, launched Gloucester Brewery with three core beers: Gloucester Gold, Mariner and Dockside Dark. The official launch took place in March 2012. A light summer beer called Priory Pale was later added to the range. A specially designed tricycle, capable of carrying six casks of ale, was introduced in the spring of 2013, which raised a few heads as staff delivered beers to city pubs. Gloucester Brewery have embraced the new generation of keg beers that use high impact hops to produce superb beers like Citra, Galaxy and Black Simcoe. The reintroduction of keg beers have been a contentious issue with some real ale traditionalists who have recollections of the cold tasteless gassy keg beer of the 1970s, but these craft keg beers have been a revelation and have attracted many more young people to

Liz Davis pulls a pint of Admiral May at the brewery launch.

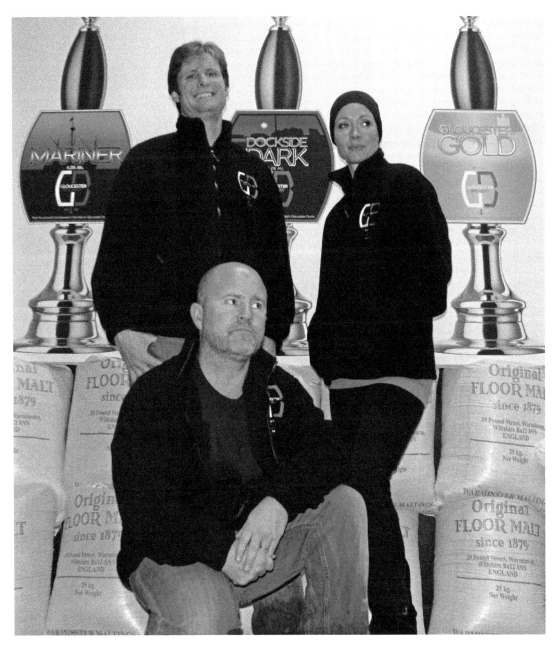

Jared and Bev Brown with Tony Hier at the Gloucester Brewery.

drink beer. Gloucester Brewery moved into a disused malthouse in the docks in 2014, which allowed them to convert their previous premises into a taphouse called TANK that showcases their own keg and cask beers alongside guest ales. Demi-God, a seasonal unfined golden ale, was recently declared CAMRA Gloucestershire Beer of the Year 2016.

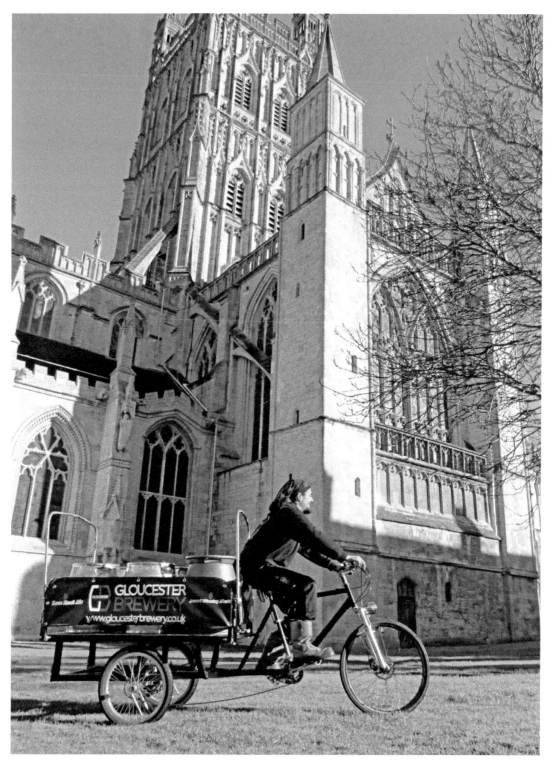

Duncan Insley of Gloucester Brewery on the delivery trike.

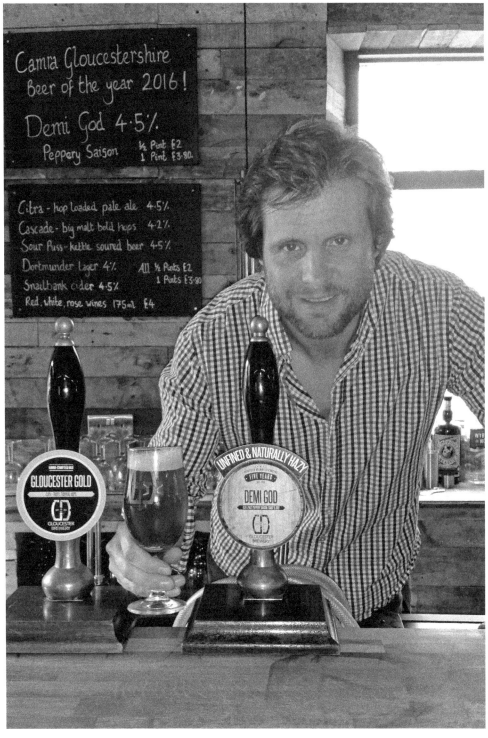

'Unfined and naturally hazy' – the addition of fish-based isinglass to clear beer is not vegan friendly.

The Bespoke Brewery in Mitcheldean, which was founded by businessman Mike Bayliss in March 2012, is located in the grounds of the former Wintle's Forest Brewery. The beers are named after old sayings or phrases: Saved by the Bell, Running the Gauntlet, Over a Barrel, Going off Half-Cocked and Kings Shilling. Another beer in the portfolio is a stout, Money for Old Rope, which has won many awards, including CAMRA Gloucestershire Beer of the Year 2012 and several SIBA honours. The success has seen Bespoke Brewery increase production by installing a twelve-barrel-length brew plant.

Andy Forbes of the Festival Brewery and Jon Kemp of the Nailsworth Brewery joined forces in 2012 to launch Cotswold Lion Brewery, which is located in the Cotswold village of Coberley. Jon had left the Nailsworth Brewery and Andy's premises in Cheltenham were proving to be too expensive so they decided to start afresh and share

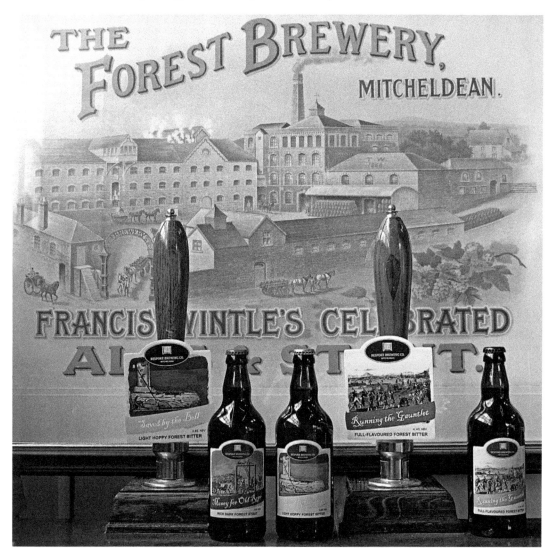

Bespoke Brewery makes a welcome return to brewing in Mitcheldean.

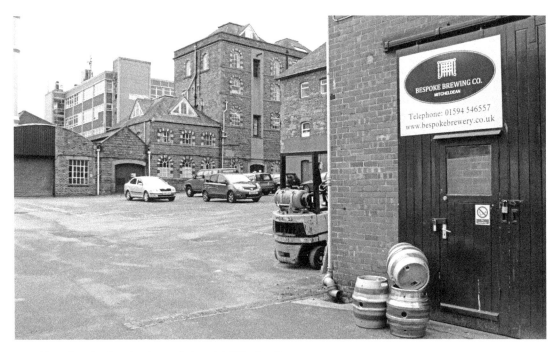

Brewing in the shadow of the old Wintles Brewery.

The Cotswold Lion is a rare-breed, shaggy-looking sheep.

their expertise. The Cotswold Lion is a rare breed of sheep, with distinctive shaggy dreadlocks, that was first introduced by the Romans. The range of sheep-themed beers includes Shepherd's Delight, Best in Show, Golden Fleece and Hogget.

Corinium Ales was set up by young beer enthusiast Lucy Cordrey and her partner Colin Knight in the garage of their home in Cirencester in November 2012. The miniscule brewery, affectionately known as Sylvia, has produced some fantastic beers, including Pliny the Elderflower, which itself was voted 'Beer of the Festival' at the Gloucester Beer and Cider Festival 2014. The majority of the production, however, is bottled, and the Roman theme extends throughout the range. Beers include Corinium Gold, a deep golden ale, Centurian, a stout, and Ale Caesar, an IPA. In 2015, Cotswold Archaeology unearthed a rare Roman tombstone in the town with an inscription dedicated to a woman called Bodicacia. Lucy and Colin brewed a golden ale to commemorate the event and labelled the bottled beer I DM BODICACIA CONIVNX VIXIT ANNO S XXVII, the precise inscription on the stone. Corinium Ales have now outgrown the use of Sylvia, and in the summer of 2016, moved to new premises called the Doghouse near the Royal Agricultural University.

Two other breweries have recently been set up in Cirencester. The Twelve Bells in Lewis Lane, Cirencester, added a one-barrel plant brewery to the rear of the pub in 2012 and Charles Malet, a former military man, established the Force Brewery on

Lucy Cordrey and Colin Knight (centre) celebrate the first birthday of Corinium Ales with dignitaries. (*Wilts & Glos Standard*)

the Global Business Park in August 2013. The premises are fully licensed, and Charles encourages customers to taste the beers and enjoy Friday events at the brewery. A golden ale called Yankee Zulu was well received at the 2014 Cotswold Beer Festival and was first in the Best Bitters class. The scallop shell used in the Force Brewery logo is the traditional symbol of the pilgrim carried everywhere in order to scoop up mouthfuls of ale while on the road.

Located in the Marsden Estate between Cheltenham and Cirencester, the family-run Tap Brewery began in 2015 and brews three regular ales: Iris, Glow and Ruby. The philosophy of Tap Brewery is rooted in tradition with emphasis on hand-pulled real ales and bottled beers. Providing a stark contrast is the ideology of the newly established Deya Brewing Co. sited in an industrial unit on the Lansdown Trading Estate in Cheltenham. Deya was set up by twenty-six-year-old Theo Freyne who is on a mission to bring American beer culture to England. He brews 'hop-freaky' ales. Steady Rolling Man is an American-styled pale ale and is exclusively packaged in kegs rather than traditional casks.

Tap Brewery, brewing in the Marsden estate between Cheltenham and Cirencester.

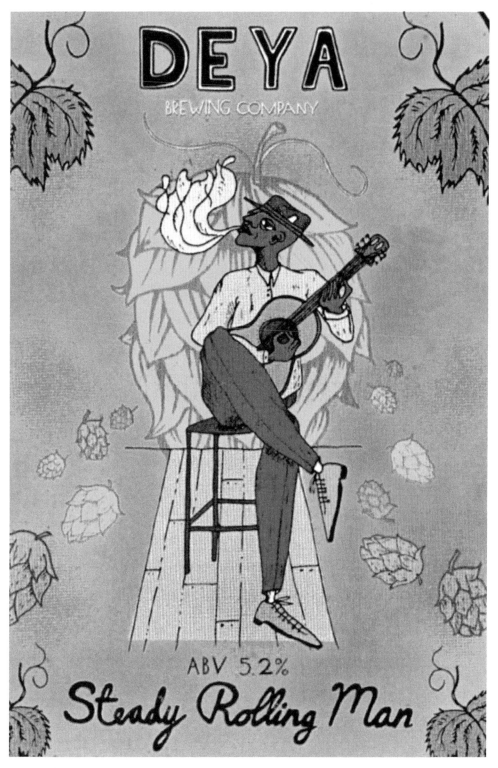

Deya, Cheltenham. Brewing with a modern twist.

Brewhouse & Kitchen are a national chain that have capitalised in the popularity of real ales and craft beers and each of their pub restaurants have an in-house micro-brewery. The Gloucester Brewhouse & Kitchen opened in the city docks in 2015 and the wide selection of beers include Shed Head, a reference to fanatical Gloucester Rugby supporters. The Cheltenham Brewhouse & Kitchen opened a year later in May 2016. Located in the Brewery Quarter, Brewhouse & Kitchen in Cheltenham has brought brewing back to the site of the Original Brewery. John Gardner, founder of the brewery way back in 1760, would have been delighted. It brings the story of brewing in Gloucestershire neatly full circle.

Small-scale brewing returns to the old Cheltenham Brewery site.

The Brewery Quarter, Cheltenham.

Further Reading

Barber, Norman, A *Century of British Brewers Plus 1890–2004* (Brewery History Society 2005).

Edgell, Tim, *Cotswold Pubs and Breweries* (Amberley 2010).

Edgell, Tim and Geoff Sandles, *Gloucestershire Pubs and Breweries* (Tempus 2005).

Haydon, Peter, *The English Pub: A History* (Robert Hale Ltd 1994).

Lovett, Maurice, *Brewing and Breweries* (Shire Publications Ltd 1981).

Peaty, Ian P., *You Brew Good Ale – A History of Small-Scale Brewing* (Sutton Publishing 1997).

Protz, Roger, *Pulling a Fast One – What the Brewers Have Done to Your Beer* (Pluto Press 1978).

Ritchie, Berry, *An Uncommon Brewer – The Story of Whitbread 1742–1992* (James and James 1992).

Saunders, John, *Breweries of the Forest of Dean, Monmouth & Ross on Wye* (Past and Present Books, Coleford 2012).

The Tippler, Magazine for the Campaign for Real Ale Gloucestershire Branches.

West Country Brewery Holdings Ltd, *200 Years of Brewing in the West Country.*